DRAW
DRAGONS
and Other Fantasy Beasts

D1219188

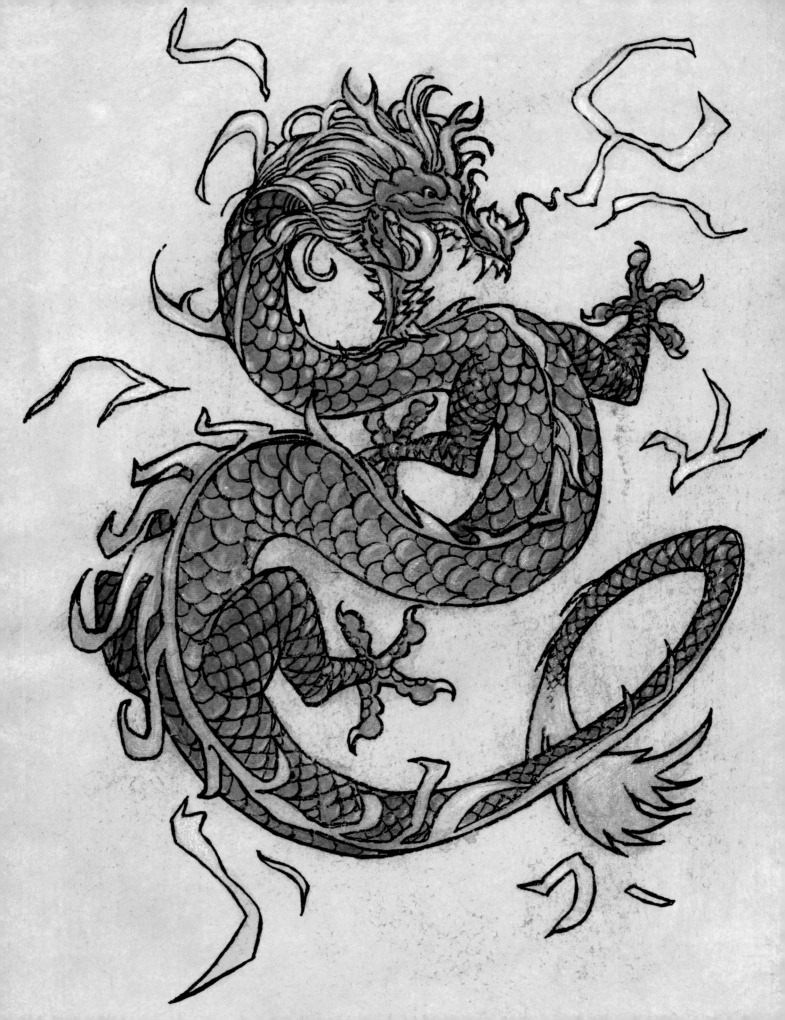

DRAW
DRAGONS
and Other Fantasy Beasts

Gary Spencer Millidge and James McKay

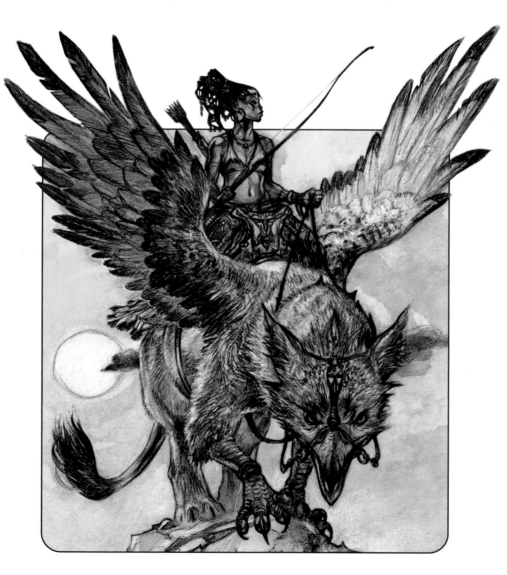

NEW
HOLLAND

Reprinted in 2011
First published in 2008 by
New Holland Publishers (UK) Ltd
London • Cape Town • Sydney • Auckland

Garfield House, 86–88 Edgware Road
London W2 2EA
www.newhollandpublishers.com

80 McKenzie Street, Cape Town 8001
South Africa

Unit 1, 66 Gibbes Street, Chatswood,
NSW 2067, Australia

218 Lake Road, Northcote, Auckland
New Zealand

ISBN: 978 1 84773 157 9

Editor: Amy Corbett
Designer: Neal Cobourne
Production: Laurence Poos
Editorial direction: Rosemary Wilkinson

Reproduction by Pica Digital Pte Ltd, Singapore
Printed and bound in Malaysia by Times Offset
(M) Sdn Bhd

3 5 7 9 10 8 6 4

CONTENTS

Introduction

Dragons, creatures of myth, giant fire-breathing lizards with claws and wings – almost every region and culture has its own dragon legends, from the ancient Greeks to the Romans, from the West to the Far East.

Saint George and Hercules have both fought the beast in common mythology, while in literature the dragon has featured in the epic *Beowulf* and Tolkien's classic *The Hobbit* as well as in the works of more recent novelists such as J.K. Rowling. The dragon has become a firm staple of books, computer games, cartoons and movies for children and adults alike.

This book aims to provide an introduction to drawing the dragon, which necessarily also involves guidance on a number of other aspects of creating art – any kind of art. To create a convincing dragon on paper, it is necessary to first learn some basics of drawing. Observation from life, particularly real animals, is required to imbue the artwork with life and realism; in other words, in order to create a believable dragon, you must ground it in reality.

Therefore, by working through this book methodically, you will learn about some of the tools needed to create your art; you will also discover some basics of animal anatomy, principles of light and shadow, and how to construct creatures from simple shapes. You will study the dragon's head, wings and other body parts and learn how to invent suitably exotic backgrounds for them to inhabit.

But this book is not only about dragons, it's also about other beasts from myths and legends and will enable the creation of your own unique and original monsters. You will learn how to draw unicorns, centaurs, griffons, satyrs and much more.

Studying the anatomy of real animals from lizards to lions and goats to birds, as well as that of humans, will give you the ability to construct your own hybrid creatures. Most real-life animals have features which you can, with a little forethought, mix and match.

For the main example illustration of each beast, you are provided with a step-by-step breakdown so that you can recreate the figure. There will also be other images that you can try to build up yourself, by using the techniques described and studying the initial layout stage and the finished version.

By learning the principles of drawing and painting real objects and creatures, you will find that accurately representing your fantasy creations on paper becomes easier and gives you better results.

Don't get discouraged if your first attempts don't look too much like the finished examples shown in this book. Every artist at one time started out as a beginner and a true artist never stops learning. No one can simply pull a beautifully rendered illustration straight out of their head without reference, preparatory drawings and lots of practice. Don't be afraid to make mistakes, as it's by making mistakes that we learn.

The secret is patience, practice, hard work and more practice. However, you should also have fun with your artwork, draw everything and anything and try to use as many different media as you can lay your hands on. Hopefully this book will give you a head start in becoming an accomplished and successful fantasy creature artist.

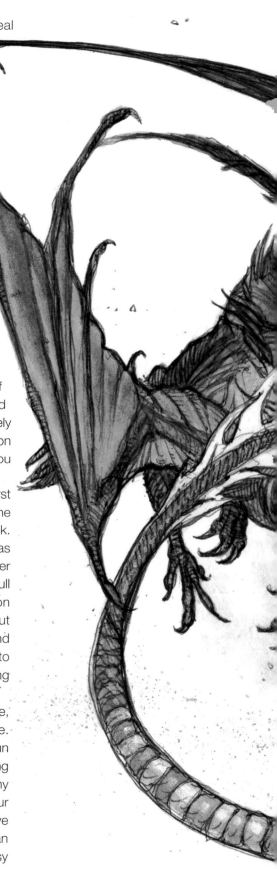

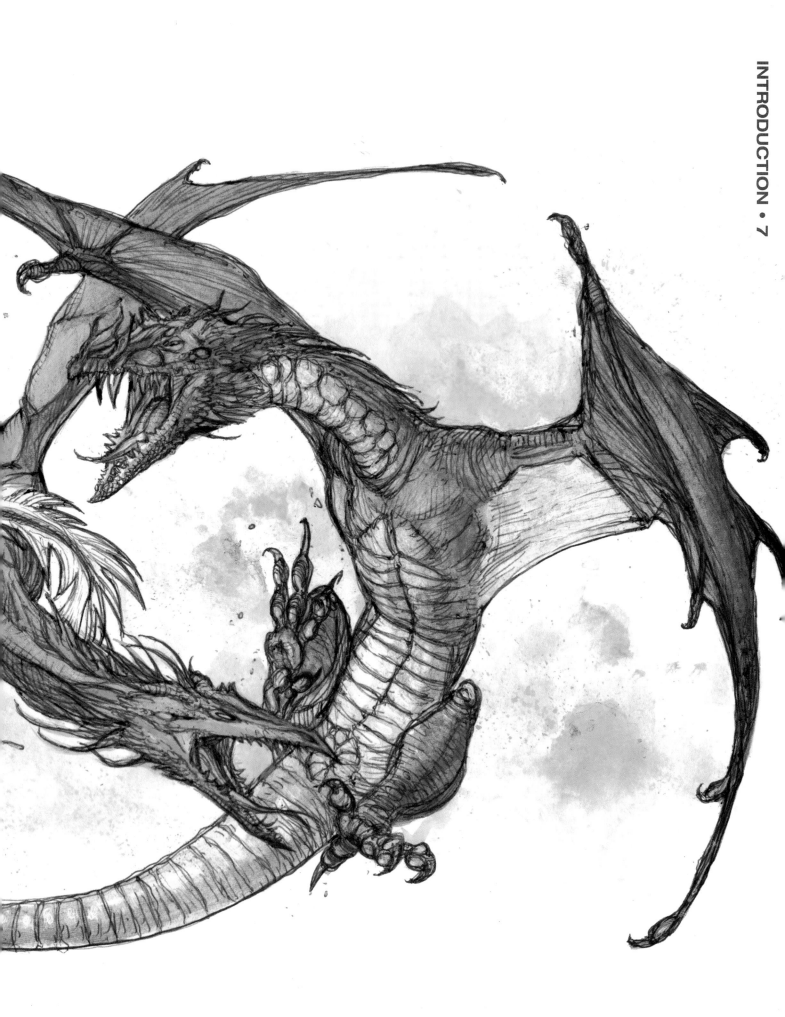

Tools & Techniques

The first thing you need to do before drawing anything at all is assemble your materials.

In fact, all you need to get drawing is simply a piece of paper and a pencil. And it's these materials with which you will need to practise with the most. But you can achieve a variety of effects and have great fun with all kinds of different tools and implements, a few of which we will cover in this first chapter.

For almost every illustration you will create, you will probably first begin with a pencil underdrawing, at least until you gain a lot of experience. Once you have sketched out all the basic shapes and details, you can add ink, paint or other media, or even complete the image as a finished pencil drawing – but in each instance, you should start with your pencil.

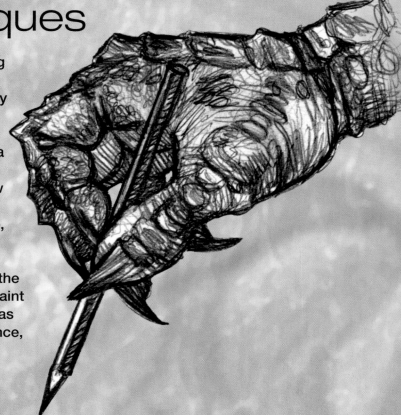

PAPERS & SURFACES

There are a large number of different surfaces available to the budding dragon artist, from cartridge papers to watercolour boards and even canvas for your oil painting masterpiece. Papers are available with smooth, 'hot-pressed' finishes, rougher finishes with some 'tooth' and even canvas textures. It's often convenient to buy papers in blocks or spiral-bound pads.

But for the beginner, and for basic sketching, use a cheap pad or loose plain paper. You will be making a lot of mistakes to start with – which is a good thing, as it is by making mistakes that you learn – but you do not want to waste good quality paper.

It is also a good idea to invest in a small, portable sketchbook which you can take with you for sketching ideas from your everyday life when inspiration strikes.

PENCILS

As with paper, there are different kinds of pencils. Softer pencils (6B being the softest) create a darker line and are easier to erase but harder pencils (6H being very hard) are more precise. Personal preference is everything, so experiment with a number of different weights. HB pencils are a happy medium and a good starting point.

Some professional artists use a waxy, non-reproducible blue pencil which does not show up on camera, although it is difficult to erase.

You will also need a sharpener for your pencils and an eraser to remove unwanted lines. Again, there are many varieties which you can try out. Kneadable putty rubbers are interesting in that they can be used to create smudging effects.

You can also buy 'propelling' pencils which act as holders for separate pencil leads that do not require sharpening.

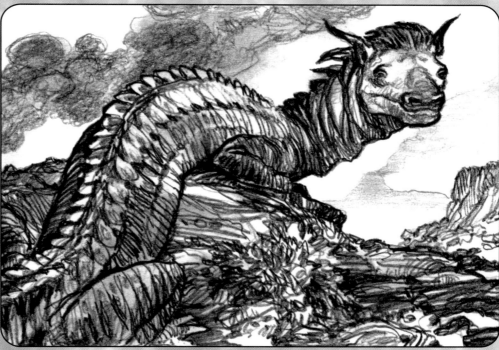

Soft pencil shading

You can see from this example that by varying the pressure of the pencil on the drawing surface, you can create a detailed, soft, gradated effect. The initial layout for the finished pencil sketch should be done very lightly in a hard lead, with the final details added later using a softer, darker pencil. Note how the smudged, scribbled effect creates a good impression of hazy smoke in the background.

By comparing this illustration with the various other rendered examples in this chapter (see pages 10–13), you can see what a difference equipment and technique can make to the same basic image.

PENS & INK

A quick browse in your local art supply store will show you the vast range of inking implements available to you.

Traditional 'crow quill' pen nibs are still available and when they are used in conjunction with a holder and a bottle of ink, they can create an ink line of varying thickness all in one stroke by adjusting your pressure on the paper. These tools are not for the faint-hearted and require a great deal of practice.

Similar 'split-nib' pens with inbuilt reservoirs of ink – like fountain pens – are easier to handle for the beginner and still provide a degree of flexibility in line widths.

Available in a number of different sizes, technical pens with fine, rigid tubes and refillable or disposable ink reservoirs are designed for drawing lines of a consistent width. These are useful for drawing straight lines, tight detailing and textures.

A flexible, convenient and affordable alternative are the range of pre-filled 'fineliner' pens, again available in a number of line widths.

Fibre-tip pens are also useful, although the tip point often softens rather quickly and some inks tend to fade over time. Thick black permanent markers can be used for filling in large areas of black.

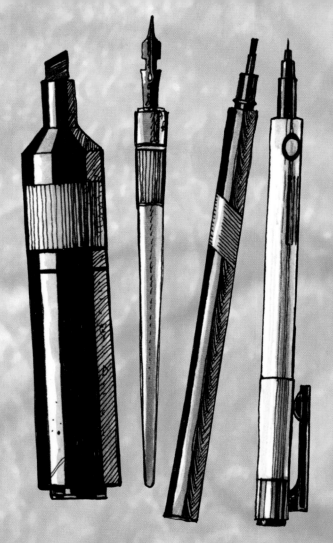

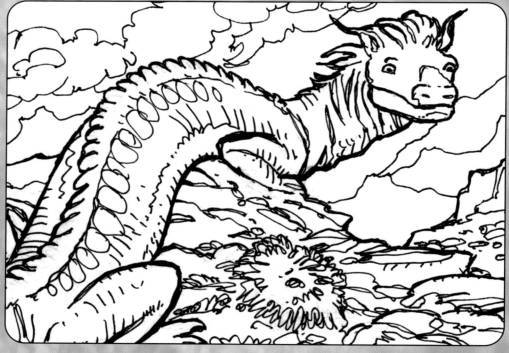

Ink outlines

This simply rendered example demonstrates that without complex shading, figures, textures and backgrounds can still be clearly defined by the weight of your ink line. The heavier outline around the edges of the foreground elements clearly separates them from the background.

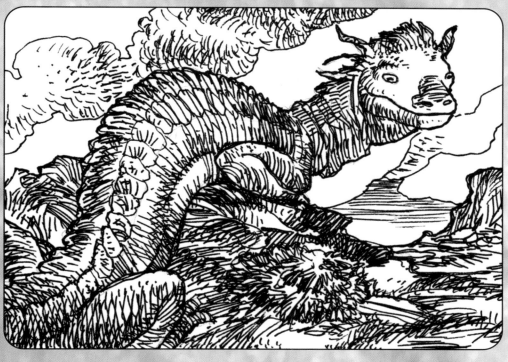

Ink hatching

Hatching – using small strokes to describe shadow and texture – is a difficult technique to master but when used correctly can add shape and detail to your drawing.

Following the contours of the figure with your hatching helps to suggest shape and form. Again, a thicker line around the edges of your foreground elements helps them to 'pop out' from the background.

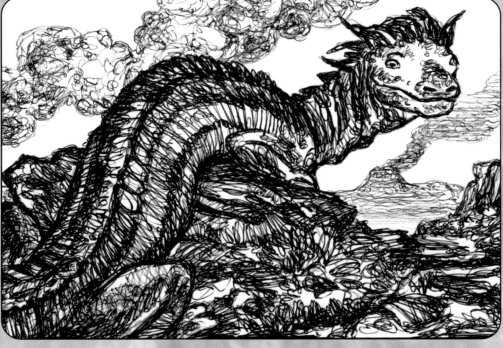

Ink scribble

This playful rendering technique was created with a 'fineliner' pen. Loosely scribbling and building up the weight of the parts of the image by repeatedly drawing

over the same line, this technique can give a more playful result. Note the lighter line used for the background elements which helps them to recede behind the foreground.

BRUSHES

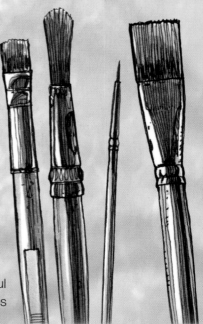

Brushwork gives a more fluid feel to your illustration and varying your line thickness from thin to thick is much easier than with any kind of pen. Many professionals use brushes for the speed they offer but they are difficult tools to master.

Paintbrushes also come in a bewildering range of types and sizes. The smaller, pointed brushes are designed for use with ink and watercolour paints. You can of course use sable-type brushes to apply India ink straight from the bottle; this is another technique which requires some experience to achieve the desired effect. Again, experiment with as many different varieties as you can, discover the tools which suit you but don't limit yourself to one single implement. Constantly trying new equipment helps you to improve and evolve your drawing technique.

Oil and acrylic paint are best served by stiffer, sometimes square-ended brushes, useful for applying thick layers of paint. These paints can also be applied by using palette knives and even rollers.

Ink chiaroscuro

By applying heavy areas of light and shade, a dramatic, almost stencil-like image can be created. There is no room for grey, only black and white: an ultra high-contrast technique called chiaroscuro.

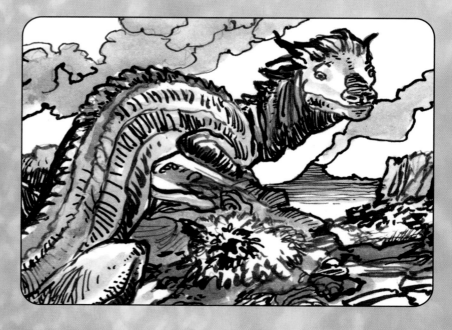

Ink and wash

A loose brush stroke gives a more 'organic' feel to rendering, especially vegetation. By diluting ink in water, here a dark sepia colour, successive layers can be built up over the image outline to suggest tone, shadow, depth, shape and texture.

COLOUR MEDIA

There are many ways to add colour to your illustrations, such as coloured pencil, watercolour, acrylic or pastels. If possible, experiment with as many different media as you can. You can even combine different techniques in your own way: translucent colour can be applied over the top of your ink drawing, like a comic book, or you can apply watercolour paint as a wash, or specialized coloured inks using a sable-type brush, or even coloured pencils.

Denser media, such as pastels, gouache watercolour, acrylic and oil paint, require a little more skill. Specialist brushes and thinners are required for some paints. Each technique has its own advantages and disadvantages though and there are many books available devoted to the different areas for the eager student to browse.

Coloured pencil

Coloured pencils are waxier than regular pencils, and as a result are more difficult to correct, so your underdrawing should always be done first with a regular lead pencil. You can enhance the outline of your image with a different colour – here dark brown was used – and applying layers of colour one over another can create gentle gradations and subtle tones and hues.

Watercolour

Again, lay out your composition in pencil first and then watercolour can be applied in monochrome to suggest shadow and tone. Translucent layers of colour can then be added, building up shape. Colours can be mixed to create realistic, earthy tones and adding blue helps to suggest shadows. Here on the dragon's back successive layers over the image outline suggest tone, shadow, shape and texture.

In creating art, there are no rules. Anything can be used to create a mark on something, be it a burnt stick on the walls of a cave or spray paints on old bed sheets: experimentation is the key. Of course, neither of the above is necessarily recommended and for the purposes of this book we will adhere to the more traditional techniques! You may however be keen to try out more exotic tools and media like charcoal, pastels, canvas and coloured papers, collage and so on.

It should also be stressed here that you should always endeavour to look after your equipment and media. Make sure lids are screwed on and brushes and pens are thoroughly cleaned and rinsed after use. Art supplies are very expensive and should be treated with care.

The key is: have fun, experiment, learn and improve.

Acrylic

Unlike inks and watercolours, paints like oil and acrylic are opaque and therefore lighter tones can be applied over the top of darker tones. It is often good practice to fill in large areas of basic colour to ensure that the colour and tonal balance is correct before adding details and further colour variations. The white highlights on the dragon's scales are the final elements to be added in this example.

Building a Better Dragon
BASIC BUILDING BLOCKS

Now you have all your equipment to hand, you will want to get started and draw dragons! In this chapter, you will start to learn how to create a convincing dragon from simple lines and shapes. But first you need to look at some boring basic drawing stuff.

▶ Virtually all parts of living creatures – indeed, all parts of anything that you would wish to draw – can be imagined to consist of simple block shapes like boxes, cylinders, spheres, cones and ovoids (or egg-shapes).

Try copying these simple shapes. Even a simple circle or block can take some practice before you get it right every time. Don't worry if your circle isn't perfect or that your lines aren't perfectly straight – you do want your personality and character to shine through even the simplest drawings.

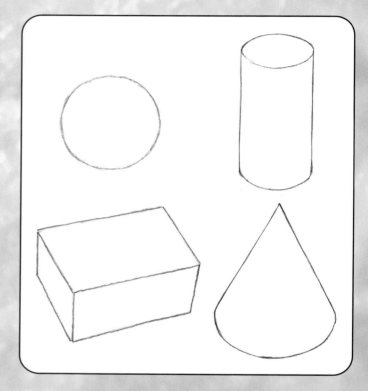

▶ The basic circle looks pretty flat. It could be just a disc rather than a sphere, or ball shape, which will be one of your major construction blocks. You need to learn to think about these shapes in three dimensions. It may help you to visualize them as if they were transparent, so you can see all sides of your objects.

It's easiest to see this with the box shape. The cylinder and cone are interesting as you can imagine them to be upside down as well as the right way up. The sphere would actually still look pretty much like a circle, so here two lines have been added around its circumference.

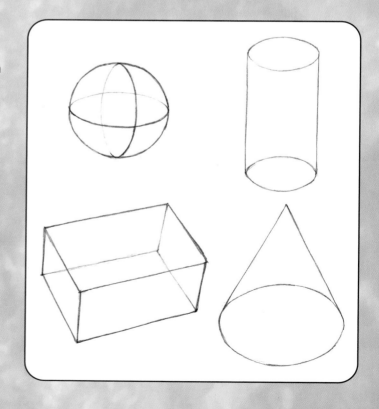

▶ OK, so you may be able to visualize your blocks in three dimensions, but how do you show that in a drawing if they are not transparent? Contour lines can help give your drawing form and mass. Skin markings and scales can help give your creatures three-dimensionality if they convincingly follow the contours of its surface.

The sphere looks as if it has been both sliced through from top to bottom and also cut into segments like that of an orange. It suddenly looks like a globe, in three glorious dimensions.

Lines at regular intervals around the box, cone and cylinder slice up the blocks as if they were loaves of bread. These surface lines give your object solidity and form.

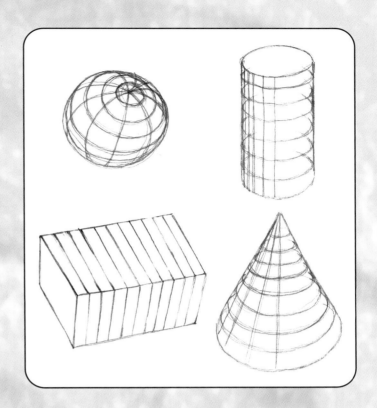

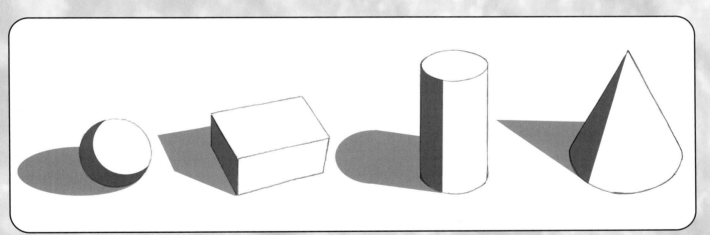

▲ Light and Shadow

Light and shadow are everything. The human eye recognizes shape by the way the light falls on objects and creates shadow. Don't believe it? Turn off the light on a particularly dark night and you won't see very much.

If you shine a light on the four blocks, they suddenly emerge into three dimensions, without the need for contour lines or having to draw in the hidden lines.

Note how each block is partially in shade as well as casting a shadow on the surface behind it. The circle becomes a sphere with the addition of a single light source (which, as in all the examples here, comes from the right and slightly above).

It is the shadow that gives the optical illusion of shape and form, and practising with these simple blocks can

give an understanding of how light and shadow work. Find some everyday objects around the house – a shoebox or a tennis ball or a can of beans. Use a light source such as a lamp to light your object. Quickly draw the basic shape and the shadows where they fall. Then move the light and draw again.

This may seem like a long way from drawing dragons but if you understand how light falls on simple objects, it will aid your understanding of drawing anything, not just dragons. Your fantasy creatures will look more like real, three-dimensional creatures as a result of your hard work here. Practice pays dividends.

You will discover a little more about light and shadow later on in this book.

DRAWING A DRAGON FROM BASIC SHAPES

Time now to build on those initial exercises.

▶ Start by drawing an oval to act as the basis for your dragon's body. You can suggest the shape of an egg by drawing a couple of contour lines. Imagine dividing the ovoid into eight pieces. This will take some practice to get right but by imagining your shapes in three dimensions your final illustration will appear much more realistic. Keep your pencil lines light and fluid and don't be afraid to go wrong. You can always erase or start again.

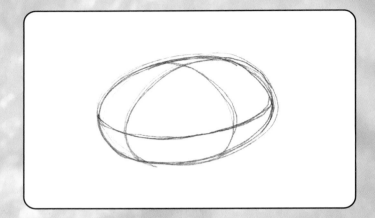

▶ Next, add a line to suggest the dragon's long neck and tail. See how the line continues from the base of the neck across the contour line of its back and turns into a tail. Around the middle 'equatorial' line, you can imagine where its legs might begin by making small marks at the appropriate points, just about halfway between the two vertical contour lines.

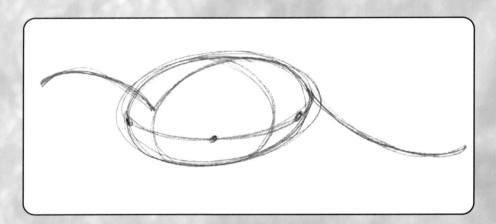

▶ Now you can extend a couple of lines from these points to represent the skeletal basis for the dragon's short legs. Add a joint about halfway down each leg to represent the knees. Note that the fourth leg is only just visible, as the dragon's torso is hiding most of it from view. This is the something else that experience and improved judgement will help you with once you learn to visualize the finished creature.

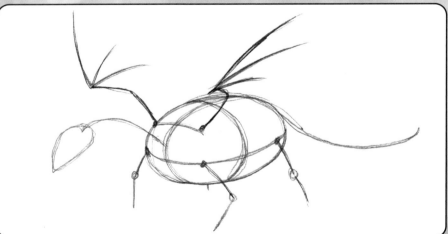

Add two points approximately in the middle of each of the top front segments as guides for the position of the wings. Extend a line from each point, kinked slightly, with three more lines radiating out from the end.

A cone shape, or a pointed oval, should be added to the end of the neck line to represent the basis for the dragon's head. The downward curve at the end of the neck line helps indicate the weight of the head.

Bear in mind that the lines for the neck, legs and wings should always be curved. Never use straight lines when you draw anything organic – plants, humans, animals or imaginary creatures – as it just won't look natural. Always use gentle curves instead.

► When you are happy with the proportions of your basic framework, you can really start building up the rest of the dragon's body. Using your simple lines to act as the centre, build cylindrical shapes around them. Note how the cylinders curve and taper – they are never straight like a drinks can. The neck and tail of your beast get slightly thinner as they move away from the body, mirroring each other.

Build up the wings with webbing between its 'fingers' and thicken up the front edge.

You can add further contour lines to suggest the shape of the neck, tail and body, and these will help you to add surface form later. Sketch in feet and toes, a pointed end to the tail and add detail to the head. Adding a second tear shape just below the head will suggest an open mouth and you can mark the position of the dragon's eyes and nostrils.

► It's time to take those final decisions and start to make firmer pencil lines. Gently erase some of your construction lines if necessary. Stiffen up the outlines of the creature. Then you can start to add smaller details like a pair of horns and spiny fins which run along the length of its back, from just behind its head all the way down to the tip of its tail. Following your contour lines, you can add texture and surface detail to suggest scales and skin. Small, regularly placed circles along the length of the body giving the impression of scales are a nice touch.

Build up the feet in the same way you built up the dragon's limbs and add claws. Maybe add a few fins on its elbows and back of its legs to give the dragon an even less cuddly persona.

Your first attempt may not look exactly like this. Don't worry. Practice makes perfect.

THE DRAGON SKELETON

All creatures have skeletons. Well, jellyfish don't, but almost all others do! That includes dragons and other fantasy creatures. Now, if you are interested in getting on with drawing flying, fire-breathing, full-of-life dragons, you may wonder why you would want to know about something you can't see.

The reason is, without skeletons, we would all look like jellyfish. The skeleton is the framework which holds the organs, muscle, fat and skin together. Study this illustration below of an imaginary dragon's skeleton. It already looks pretty much like a real dragon, doesn't it? Serious students will probably want to study animal anatomy in some detail – not just bones but muscle and fat tissues – in order to fully understand how a dragon might look and move. Fortunately, this is not essential for the beginner and it is more important at this stage to experiment with different figures of your creation and really enjoy the drawing process.

As you will see later on in this book, dragons can be imagined as being constructed with different parts of real creatures; for example, dinosaur skeletons on display in museums can be an excellent source of inspiration. From this drawing, you can see that the skeleton has been created from a ram's skull, a crocodile's body and a bat's wings. A few interesting little kinks are thrown into the mix too, like the detail on the end of the tail. The result is very convincing. This imaginary creature's skeleton provided the basis for the stage-by-stage dragon you have just drawn and the skeleton makes an interesting comparison to the early stages of your construction.

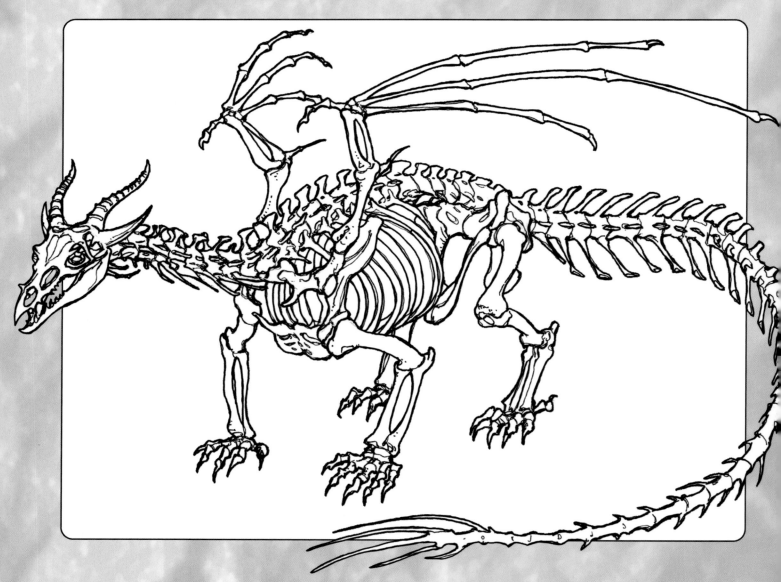

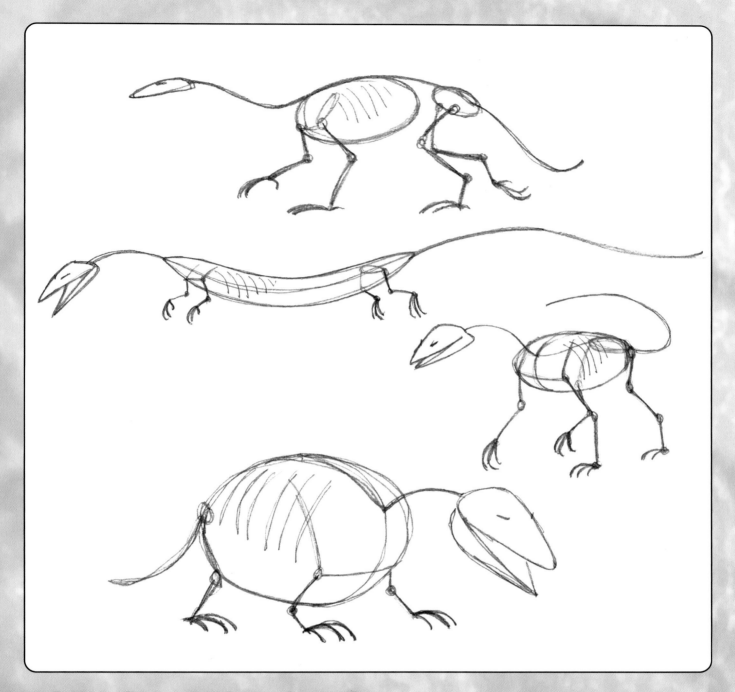

BODY SHAPES & SIZES

You don't want all your dragons to look the same. Well, maybe you do, but there is no real need for them to look identical. Just like humans, they can be stocky and fat, thin and elegant and anything in between, which creates character and interest.

By simply varying the size and shape of your basic building blocks – the ovoid body, cone head and the curved lines of the neck and legs – you can create a huge variety of shapes and sizes for your dragons.

Take a look at these examples above. A proportionally large, rotund body and short limbs combine to create a

jolly, humorous looking creature. A more slender abdomen with long limbs gives the drawing a lithe, athletic look, while the extended ferret-like body adds a certain grace to the figure.

Copy the outline shapes of each and try to build them up into finished drawings like you did earlier with the first example. You can even try to add wings if you are feeling confident. Try to create your own body types, or you can base the initial structure of your creature on any animal you can imagine and build up your own dragon design from there.

Dragons in Action
THE ACTION LINE

Dragons may not really exist but you will still want to breathe life into your drawings by starting with the action line – sometimes called the centre line or line of motion.

 This line, drawn quickly with one swift stroke of your pencil, should encapsulate the movement, balance and direction of your creature in a single line. It provides the basic backbone for your figure from which you can 'hang' the rest of its body parts.

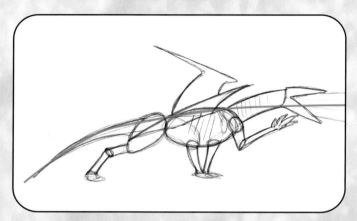

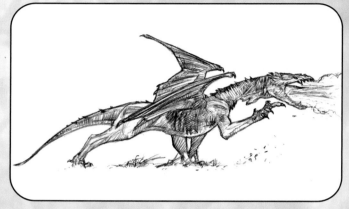

▲ Our first example is a straightforward side-on view of a dragon in a standing pose. He is leaning decidedly forwards, breathing fire, almost as a warning signal. His hind legs are apart, suggesting a big step forward, his right foreleg in the air suggesting a clawing motion. The creature's weight is on its left side as well as leaning

forwards, which makes his simple yet threatening stance more realistic.

 The action line extends from his tail, along his backbone and out through his mouth. The dragon's neck is raised higher than the action line but the essential movement and pose is still forwards.

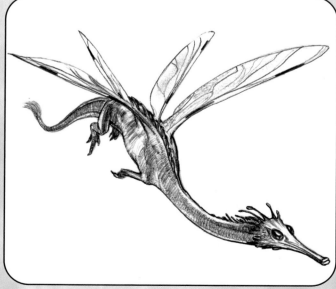

▲ This curious yet elegant dragonfly-inspired dragon is flying so gracefully it is almost as if it is swimming underwater, an illusion aided by the seahorse-like head.

The smooth curve of the action line suggests a supple flowing movement and its dual sets of gossamer wings provide a counterpoint to the action line itself.

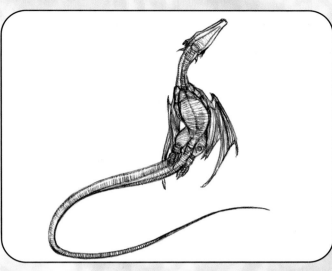

▲ This slim, elegant dragon is seen from beneath as it soars into the sky, flicking its tail, again almost as if it were a fish. The long, convoluted action line provides the basis for its backbone, from which you can hang an extended snake-like tail and crocodile-based body and head.

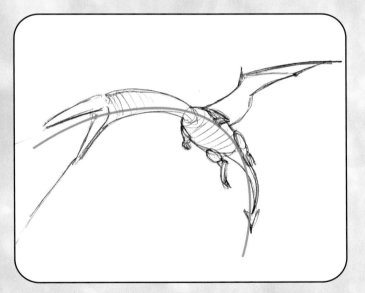

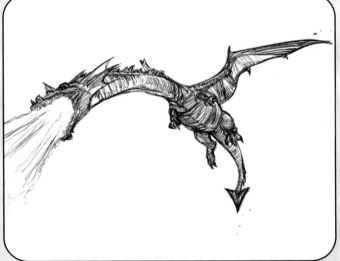

▲ The final example sees a dragon in flight, curving down to attack some poor unfortunate creature on the ground. The action line perfectly describes the arched spine of the terrifying flying monster.

There are two things of interest about this picture. The first is that the right wing of the creature is partially hidden behind its body. It can sometimes look strange if a body part is hidden entirely, as it could be perceived as missing altogether. The fact that you can see the very tip of the wing helps the mind to fill in the hidden part. You know that the rest of the wing is there, without actually seeing it.

Secondly, the head of the creature appears to be proportionally much larger than it should be. This is because of the effects of perspective and foreshortening, meaning that the parts of the dragon that are closer to the viewer appear larger than the parts which are further away. This results in the rather effective and dramatic tapering of the dragon's body. Perspective and foreshortening are more advanced techniques and you shouldn't worry about them too much at this stage; however, it is a good idea to be aware of them.

The action line is always a good place to start your drawing. Always keep it smooth, curved and full of grace. You don't need to adhere to it exactly but build upon it to provide your figure with a sense of life and movement.

POSING YOUR DRAGON

Now you have some ideas on how to construct a basic dragon from simple shapes and how to charge life into them with your action line, you should think about in which pose you want to draw them. You may wish to think about what the dragon is doing, what he is thinking, how old he is and what is his current mood, among other things. You can then consider from which angle you wish to draw him and in which setting to place him. Maybe he is preparing a meal for friends to celebrate his birthday, trying to cook a stew over a camp fire while reading a cookbook, worried that he may not have added the right ingredients. Or maybe he is just flying down from the sky to make toast of an unsuspecting armoured knight.

 The choice is yours but all these elements can be used to add life and interest to your figure, to make your drawing convincing and believable.

▶ Imagine the pose you wish to create. Then draw your action line and build up the body with simple curved lines and shapes, placing the limbs, neck and wings in the appropriate places. Keep the shapes simple here, as it may take you several attempts before you get it as you want.

 This dragon, seen from the side, seems quite happy ambling along, perhaps about to take off. Note how his hind legs hang from the top of the back end of the abdomen, while the front limbs hang from the underside.

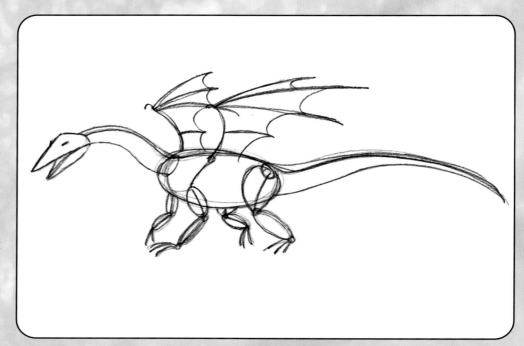

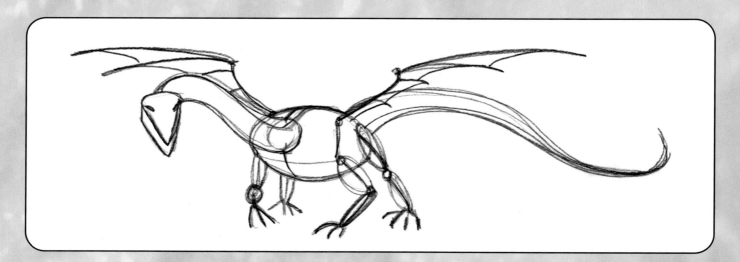

▲ If you rotate the view of the figure so that you are looking at it front-on, you will discover that the body seems to be a slightly different shape due to the effect of foreshortening. Curling his neck out to its left and his tail to the right will give the pose more balance.

▶ The weight of this character is very much on its right hind leg, as it rears up, standing almost vertically in order to roar its annoyance at something. The upward curve of the tail neatly balances the figure physically, as well as the picture compositionally.

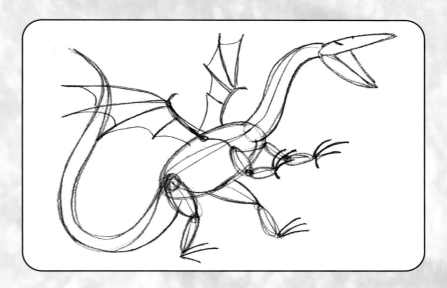

▶ This example shows a rather unflattering rear view of a creature, presumably in a hurry to get away. The furthermost parts of the figure, his neck and head, appear proportionally smaller compared to his rear end because of the exaggerated perspective of foreshortening. A cute curl of the tail adds balance and compactness to the design and the hint of the right foreleg solidly grounds the figure.

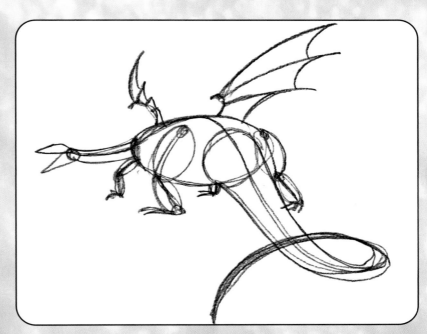

▶ All creatures sleep and dragons are no exception. Observing other animals, even your family pets, can inspire you to create new poses for your figures. Again, the abdomen is foreshortened or flattened because of the front-on view but the tail and neck are placed to the sides, adding interest and balance.

Remember to always start with a simplified outline of your pose. Unnecessary details can confuse and make your basic construction inaccurate. Once you have a well-balanced, correctly proportioned figure, in the pose you require, you can start adding all the fun details.

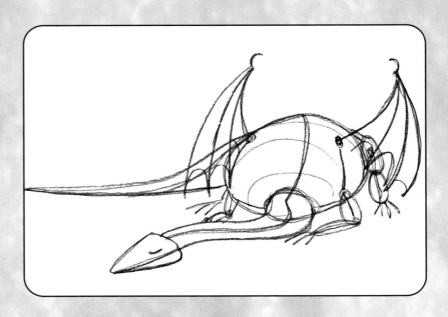

Dragon Heads

In this chapter you will learn how to draw the dragon's head in more detail: its constituent parts, the view of it from different angles and with various expressions.

IN PROFILE

▶ As always, start with the basic outline of your image, thinking in terms of basic shapes. Getting all the proportions correct at this stage will save a lot of heartache later. Stripped down to its simplest shapes, the profile, or side-view, consists of a split cone and a curved cylinder.

▶ Next you need to refine this outline, adding some elegant curves so that you now have something resembling a snake with an enormous beak.

Note how the dragon's jaws are open, warning off anyone venturing too close. Keep your pencil lines light and gently sweeping, giving the shape grace and life. Imagine the jaws as a beak, sitting over its thick, muscular neck. Add some horns protruding from the top of its head and suggest a flickering tongue with a single line.

You should try to keep your drawings loose at this stage and not to worry about getting every line in the right place, but instead concentrate on giving your drawing energy and shape.

▶ Once you are happy with the basic shape, you can progress to adding a little more detail. You can sketch in some rather small, aggressive-looking pointed teeth, suggest some fins running down the back of its neck and add design and textures to the top of its snout and around its horns. This dragon will have two sets of nostrils, which come in handy when you breathe fire.

▲ A lot of the surface textures can be suggested by simple lines and oval shapes. Always remember to think of what you are drawing as a three-dimensional object and that the surface shapes will be distorted by the figure's contours.

You can add a large, terrifyingly vacant eye and more detail to the nostrils and its scales by simple oval shapes. A few lines following the contours of the neck add shape and some irregular spines jutting backwards from the neck add further aggressive elements. Once the main detail has been planned out in pencil, we can ink our evil dragon's head.

▲ Don't plan every last line before you trace it with a permanent outline: not following your pencil underdrawing too slavishly and adding some of the minor details directly in ink will give your finished image more life. This gets easier as your confidence in your own drawing ability grows, so don't worry if you make mistakes.

You may want to gently erase some of the pencil before you start to ink. You can add smaller scales by drawing more ovals and circles and add shading with thin parallel lines following the contours of the head. Small bumps are added to the top of the snout and you can enhance the horns with ram-like ridges. A thicker line is added around the edge of the head, helping to give the image a more dynamic shape and helping it 'pop' off the page.

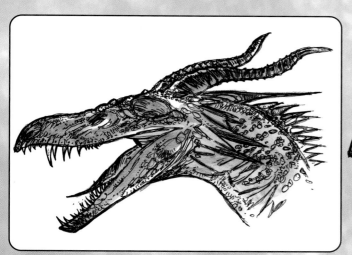

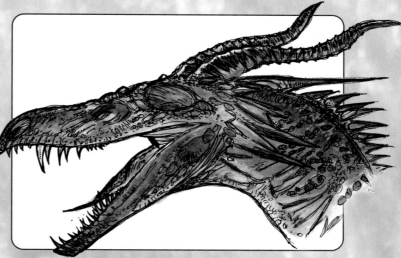

▲ Some simple colouring techniques can give this image further impact. For the basic colour, a quickly applied watercolour wash in green and brown gives an initial and effective result. Don't try to get the colour too even. The variation in tones (by mixing or diluting the paint) gives a slightly uneven but more realistic effect.

▲ You can finish your evil dragon head by highlighting and reinforcing the tones with further layers of watercolour and perhaps colour pencil, giving more depth and weight where necessary. Red and yellow pencil applied in layers give the image a final, polished and energetic finish.

FROM DIFFERENT ANGLES

You will not always want to draw your dragon head in profile; if you do, that might be rather boring, as there are many different angles from which to view your dragon head. You will want to be able to draw all of them if the need arises.

Remember that the actual construction of the head remains the same, no matter from which angle you choose to view it.

▶ As always, simple, basic shapes are the best place to start. Try not to think of these as flat, two-dimensional shapes but try to see them as three-dimensional building blocks which can be moved and rotated through space.

You have already constructed the profile view from no more than a split cone shape and a curved cylinder. Here we bring in a sphere, placed in between the two. This will act as a ball joint than can be rotated from the end of the creature's neck. This is a three-quarter view of the head, an angle that will probably be more useful than any other.

Each of the examples here is accompanied by a rather more sculpted, intricate version of the dragon's head, made up from a larger number of geometric shapes. It is not necessary to build up your illustrations to this degree before rendering, but studying these will help your understanding of the three-dimensional complexity involved.

▶ This view is from the other side of the head but from a slightly more full-on angle. You can see that more of the sphere is hidden, the horns appear closer to the eyes and that the cylinder of the neck is visible between the dragon's horns, all clues that the head is oriented more towards the viewer.

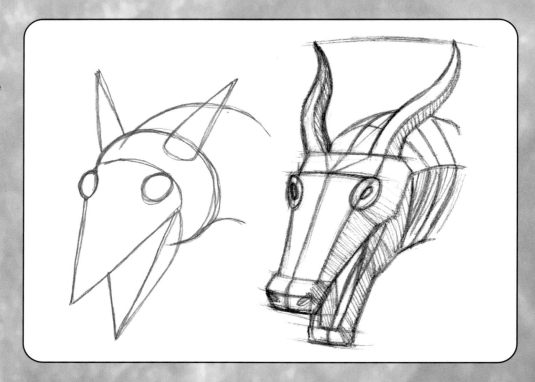

► Next, a simple view from directly above the dragon head. Notice how the sculpted version streamlines and incorporates the horns into the skull. The neck is bent slightly to add life and motion to the drawing.

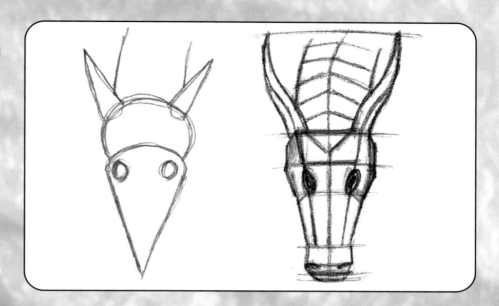

► This view from almost directly behind the head demonstrates the usefulness of the shape-building technique. It is much more difficult to create a head from this kind of angle without first visualising and drawing out your basic shapes. The back of the neck and the sphere of the head almost entirely hide the dragon's face and snout.

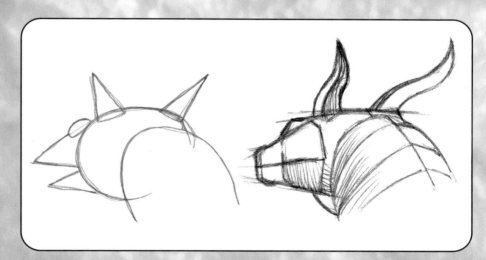

► In this view from beneath, the face (except for part of one eye) is again almost entirely obscured by the underside of the neck and chin. Only one horn is visible. The sculpted version indicates the contour lines and suggests shading which gives the creature three-dimensional form. The angle is dramatic and gives the dragon an air of nobility, illustrating that the right view of your subject can potentially enhance your drawing greatly.

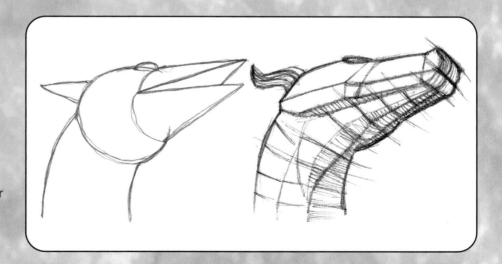

These are, of course, just a few of the almost infinite number of different angles from which you could view your dragon head. Copy these and then try to create some of your own. Try to alter the pose of the dragon's neck. Bending the neck so that the head is swooping down, raised high into the air or curved to one side adds even more character and interest to your figure.

EYES, HORNS & SNOUTS

Eyes

Now it's time to look at some specific parts of the dragon's head in more detail, starting with the eyes.

▶ Eyes are fun to draw but, as always, it's important to think about the underlying structure. Eyeballs are spherical in shape but you can only see the small part visible between the eyelids. It's the eyelids that give the human eye its characteristic almond shape while most of the eyeball remains hidden in the eye socket.

The iris and pupil are usually concentric circles; they are also often partially hidden by the eyelids. Note the white highlight reflecting off the pupil and iris. This is a neat trick which always brings any eyeball to life.

This example is similar to a human eye, with the obvious exception of the reptilian eyelids. The extra ring around the iris is the other major difference. Later in this book you will see how to construct other fantasy creatures, so below are some examples of eyes from the animal world which you can adapt and incorporate in your own designs.

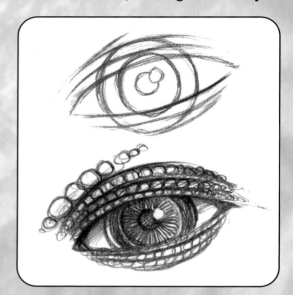

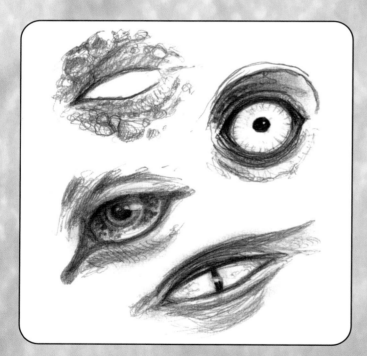

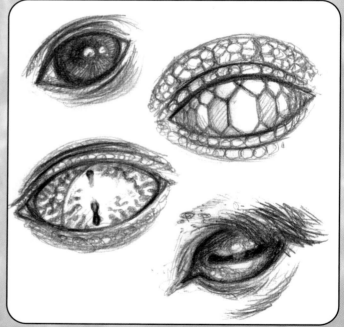

▲ Here we can see that having no pupil or iris at all gives the eye a cold, evil, emotionless character, whilst a circular, wide open eye with a small pupil and bloodshot whites creates an aggressive, fierce expression. You can even take inspiration from tigers: the mammalian eye suggests a softer, more intelligent personality. A slender, half-closed eyelid, with the elongated feline pupil, gives the impression of a sly, cunning creature.

▲ Eyes with large, dark pupils usually suggest a softer character, more youthful and perhaps more thoughtful. A large, multi-textured eye is more typically reptilian, like that of a snake or a gecko.

The multi-faceted, insect, or jewel-like eye is another example of the huge variety you can utilize in your creature designs and the slit-like, horizontal pupil of a goat or a squid gives the impression of a very alien, otherworldly being.

Horns

Horns, like almost every part of your dragon or fantasy beast, are another area where you can study examples from the animal kingdom and adapt them to fit your own creations.

▶ The dramatically ridged horns of a gazelle could make a suitably aggressive adornment for your dragon. You can see from the placement of the contour lines how the ridges can be shown to wrap around the horns convincingly. Remember that the horns, like most aspects of your creatures, should be symmetrical. Being aware of 'negative space' – shown here by an imaginary oval between the horns – can help your visualisation a great deal.

The flat, smooth tusk-like horns of a bison are very different, in that they protrude out at right angles to the head, but they can be equally useful to study.

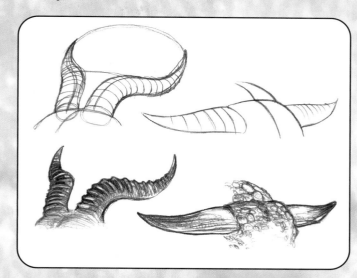

▶ The ram's horns, meanwhile, are dramatic and involved: two sets of horns spiralling and pointing in almost every direction. These evil-looking yet beautiful horns can provide a distinctive touch to your creature design. Again, take note of the way the ridges follow the contour lines of the warped and tapered cylinder shapes.

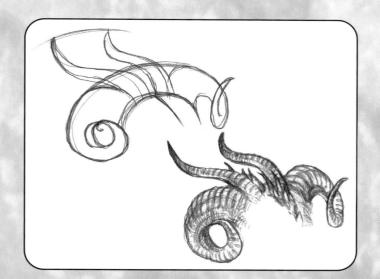

▶ The rich head of hair that is the lion's mane can be adapted for numerous beasts and can give quite a distinctive character to a dragon. Hair can be difficult to illustrate but as always, simplify it and draw clumps of hair rather than individual strands.

A lizard's frills and fins can also be adapted, not just as head adornments for your dragon, but for other parts of your dragon's body such as shoulders, ankles and tails. They are similar to a wing in construction, with thin webbing stretched between bony spines.

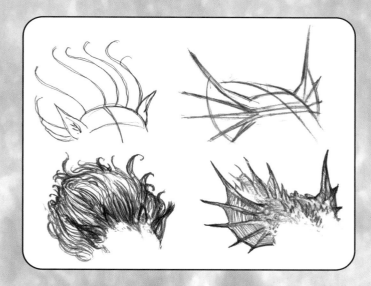

Snout

The snout of your character is its nose, jaw, mouth and chin in one. Again, you can use influences from other creatures incorporated into your own dragons and fantasy beasts to add variety and uniqueness.

▶ Crocodile and alligator snouts are certainly the most obvious areas of study for the dragon-drawing enthusiast. Large nostrils, pointed teeth and scaly skin can be readily adapted for an aggressive-looking, fire-breathing lizard of the skies.

The more rounded and friendlier-looking snout of the extinct brontosaurus is a happier alternative.

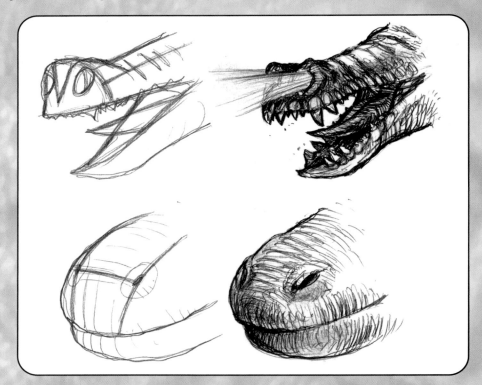

▶ By combining the two previous examples, we end up with a round, friendly snout, large nostrils and sharp teeth. Add a few drooping whiskers and you have a whole new snout to build a creature around.

The sharp, spiky and rather nasty looking beak of a giant bird can also be adapted for use for a particularly unpleasant dragon, or perhaps as part of a chimera – a beast made up from parts of different animals. A bird-like beak shouldn't have any teeth as they have no gums to grow from. Note also the snake-like forked tongue.

Attempt to copy these various head parts and then try to research some new ones of your own. Observation from life, television, books and the internet can all be used to gain inspiration for your fantasy creatures.

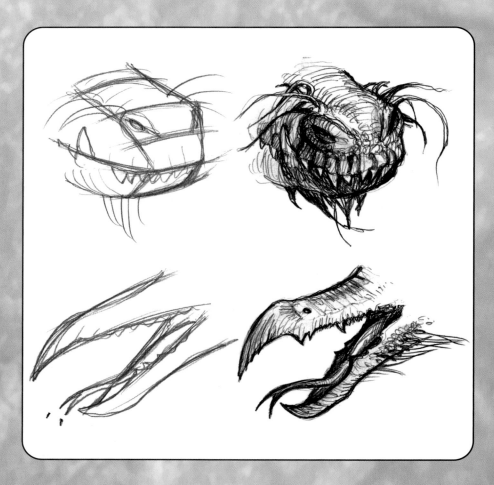

EXPRESSIONS

Expressions on your creatures' faces add another layer of character and interest to your drawing. As you will see here, with practice your creations will be able to express the full range of human emotions. In each example, you can see the human expression, with a basic dragon equivalent and a fully rendered pencil drawing. You can spot the many similarities despite the huge difference in face shape. Most artists usually have a mirror to hand at their drawing desk, so they can observe themselves to draw from. This is not generally useful for a dragon artist, unless you are in fact a dragon. But it is still a very handy skill to be able to pull a particular expression into a mirror and translate that to your fantasy beast illustration.

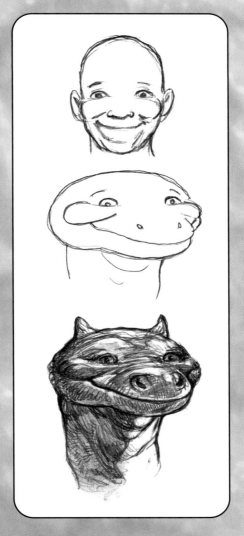

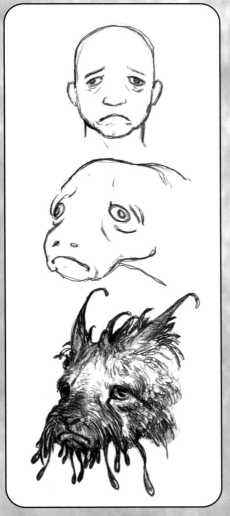

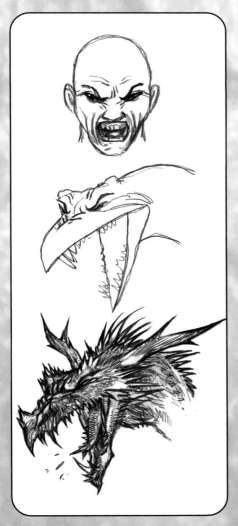

▲ A smiling, happy face is characterized by an upturned mouth and the bulging of the cheeks. The eyebrows are arched upwards and the eyes are wide open and bright, with a slight convex curve to the lower eyelids.

▲ A sad expression is often droopy, with everything downturned. The ends of the mouth sag and the upper eyelids droop over the pupil. The eyebrows point upwards towards the centre and there is a suggestion of a fold of skin underneath each eye. It is interesting to note that dogs with a lot of skin, like the bulldog or bloodhound, are always characterized as being sad.

▲ Anger is often illustrated by a wide open mouth, forehead pulled into a deep frown, eyebrows turned down at the centre to meet the eyes with the nose wrinkling up. Folds of the skin around the mouth accentuate the expression.

VARIETY OF HEADS

This chapter has demonstrated just some of the different aspects which you can experiment with in order to create the head of your fantasy beast. Here are four more heads of unique creatures freshly invented by mixing and matching different parts.

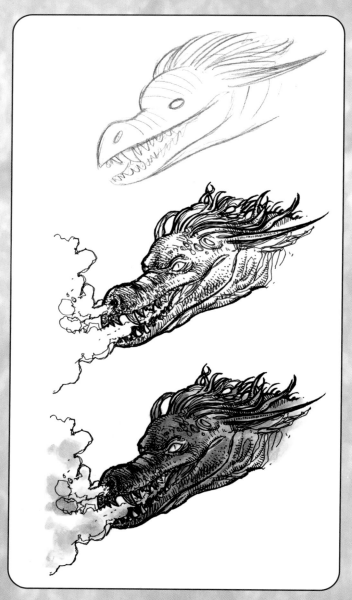

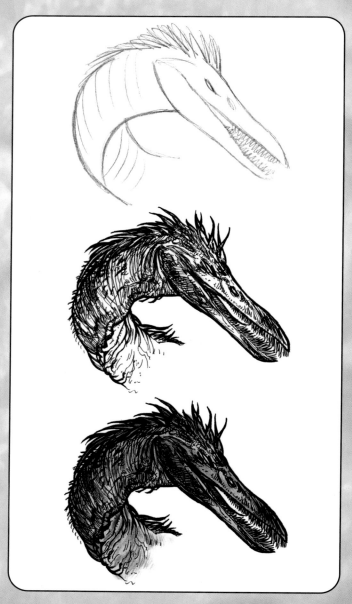

▲ A side view of a smoke-snorting dragon. Despite the fire-breathing, the slit-like cat's pupil, pointy teeth and mildly irritated expression, the creature's rounded snout and lion-like mane softens his character a little. Perhaps this dragon isn't so bad after all, maybe he's just misunderstood.

Note the way the short, jabbed hatching describes the shape of the head and provides texture to the skin, giving a leathery or lizard-like hide.

▲ This prehistoric-looking stork creature is also in a profile view but its long neck curling round makes a pleasingly balanced composition. It has a long beaky snout, expressionless white eyes, numerous saw-like teeth, a short mane and matted fur. Less human-looking, perhaps more animal-like and less intelligent, the slightly open mouth indicates that it may be about to let out an unpleasant throaty squawk.

The hair-like rendering on the snaking neck of the animal cleverly follows the contour lines and therefore dictates the shape of the creature's neck.

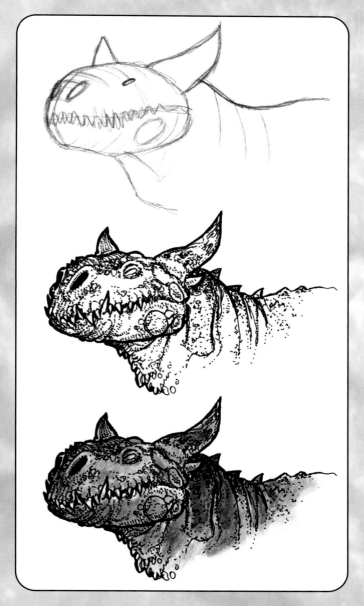

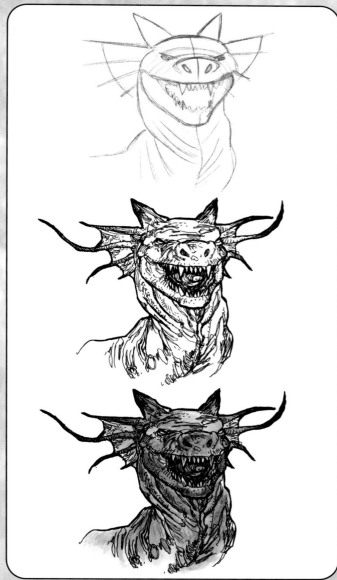

▲ Based on a rhinoceros or hippopotamus body shape, with upstanding bull's horns, enormous nostrils, haphazard teeth and a scaly skin, this chap looks rather pleased with himself about something. His smug smile is enhanced by his raised eyebrow ridges and he looks almost friendly enough to pet.

Note how the thick folds of the creature's skin follow the contour lines of the three-dimensional surface, adding shape to the drawing. The skin is rendered with dots and small circles, indicating a tough, pebbly hide. The blue colouring adds a further sense of calmness to the affable monster.

▲ This is one creature that you would not want to make friends with. The open mouth and flared fins either side of his head, and even his reddish hue, are distinct warning signs. The random spines, webbing and scaly skin all add to its rough-and-ready, seasoned fighter appearance. Again, the rendering on the neck follows the contour lines to help suggest shape and form. The angle of view is almost full-faced but with that thick, powerful curving neck which looks as if it may lash out at you at any moment, everything about this character is aggressive.

Try to copy these examples, starting with the basic shapes shown here and build them up into finished drawings. Don't worry if they don't look exactly like these; it will take time to hone your skills. Try mixing and matching various elements of dragons' heads in order to design your own dragon or fantasy beast head. Have fun, be bold and experiment.

Body Parts & Surface Form

LIMBS

Now that you have studied various aspects of the head, this chapter will deal with the other parts of your fantasy beast's body, from its limbs, wings, claws and tail to its scales, fur or feathers.

How many limbs does a dragon have? Are they arms or legs? Do you count the wings? These are some of the questions an artist should be asking before starting to design a beast. The answer to these questions is anything the artist wants, as after all, dragons are creatures of fantasy. So long as the limbs look convincing and connect to the body in a believable way, then your dragon may have as few or as many as you like. Most of the dragons featured in this book have two forelegs (or 'arms'), two hind legs and a pair of wings, although rarer creatures could have no forelegs at all or four legs as well as wings and arms. The choice is yours.

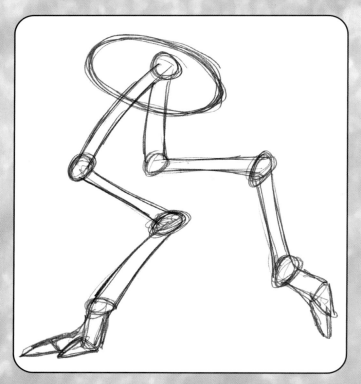

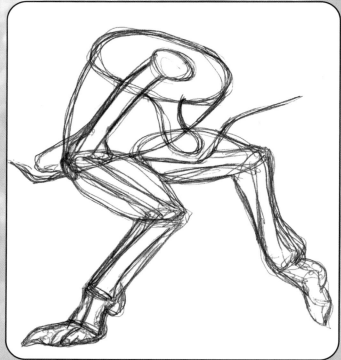

▲ Hind legs are essential to any creature's design, so take a close look at them first. They are usually larger and more muscular as they bear the weight of the whole animal. It may look like the knees bend the wrong way but this joint actually corresponds to the human's ankle.

From the top downwards, you can see the thigh bones extend from the hips (indicated here by an oval), with the shin bone bending backwards from the knee joint and then the extended foot bending forwards from the ankle joint. The final joint is actually where the toes of the creature are attached, or as in this case, its cloven hoof.

Note that each of the bones is of a similar length. The leg to the right is the creature's right leg, furthest away from the viewer. The thigh bone appears shorter but this is because it is slightly distorted by foreshortening.

▲ Now you can flesh out the bones with cylinder shapes. The thigh needs to be very strong and muscular – in this example it is almost the shape of a leg of pork. Note how the knee barely extends lower than the belly of the beast. The shin carries less muscle tissue and the foot part less still. Again, animal observation is incredibly useful in designing convincing fantasy creatures.

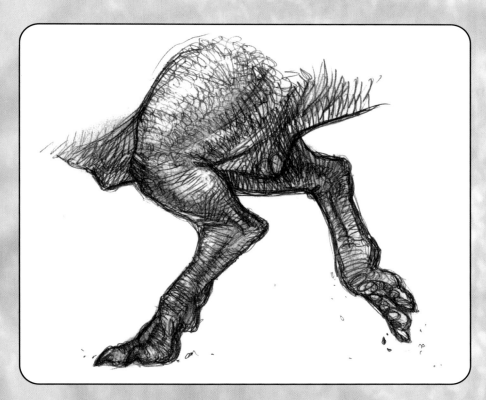

◀ Entirely covered with flesh, muscle and skin, these dinosaur-like hind legs look like they could carry the heftiest dragon. The pencil rendering follows the contours of the skin, giving shape, form and mass to the finished drawing.

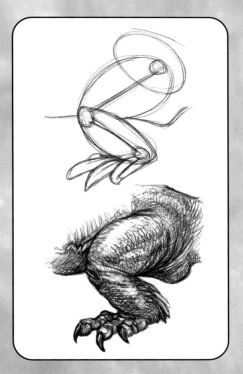

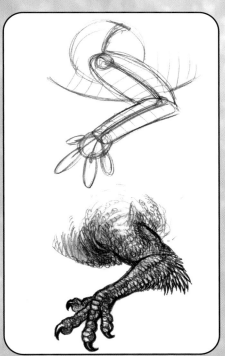

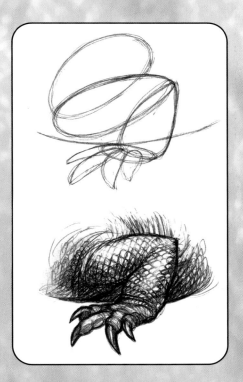

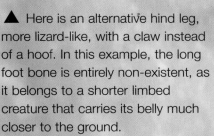

▲ Here is an alternative hind leg, more lizard-like, with a claw instead of a hoof. In this example, the long foot bone is entirely non-existent, as it belongs to a shorter limbed creature that carries its belly much closer to the ground.

▲ Forelegs are often more like arms. The upper arm extends from the shoulder and joins the forearm via an elbow which bends backwards and terminates in a claw or paw, attached by the wrist. This example could in fact be human, but with a claw in place of a hand and added feathers.

▲ Here is another example, again more lizard-like, of a foreleg, with shorter, fleshier limbs and a large paw, again carrying its body only a short distance from the ground.

WINGS

Leathery, bat-like wings are one of the main characteristics of the dragon's body. In fact, the study of all manner of creatures' wings is incredibly useful when creating other fantasy beasts, like Pegasus, a griffon or assorted chimera. Take a look at these.

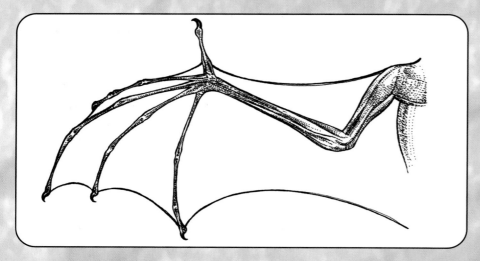

◀ Without doubt, the wing of the bat is the nearest thing on Earth to a dragon's wing. Its underlying structure can easily be seen as a distorted arm with elbow, four fingers and a thumb, albeit in greatly exaggerated proportions. A thin layer of skin stretches between each finger, creating the distinctive webbing effect.

The slightly curved bones are also jointed like human fingers, and note how the 'thumb' extends upwards.

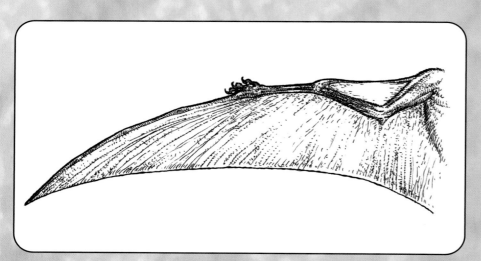

◀ By contrast, the wing of the extinct prehistoric pterodactyl is supported by a single bone along the leading edge of the wing. The 'hand' is present, but the fingers do not extend across the wing's surface in the same way that the bat's fingers do.

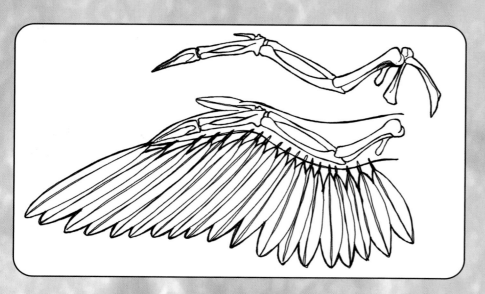

◀ A bird's wing also has a bone structure similar to an arm. Note the shoulder, elbow and wrist-type joints. There is also a small 'thumb' bone. This illustration shows how feathers are attached to and extend from the top edge.

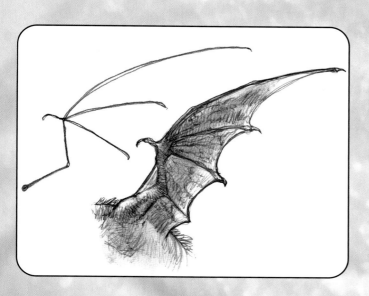

◄ Basing the wing on a bat's, start drawing simple lines to represent the fingers: an upper part, lower part, three long bony fingers and the upward pointing 'thumb'. The longer bones flex with the skin stretched between them. Once you can place these with confidence and accuracy, the rest of the wing becomes very much easier to draw.

Build up the 'arms' with fleshy cylinders, tapering as they extend from the body of the creature. When adding the leathery webbing, note the additional spine at the bottom of the elbow, the curve of skin between the ends of each finger and also a little more skin stretched between the shoulder and thumb. A few wrinkles added between the fingers add to the stretched leather effect.

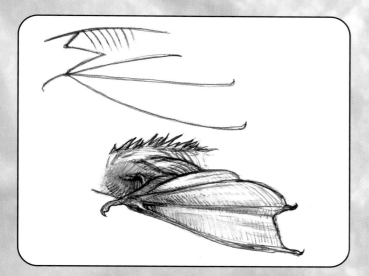

◄ In flight, viewed from the side, the skin can be seen billowing out slightly. From this angle, the effect of foreshortening is very apparent.

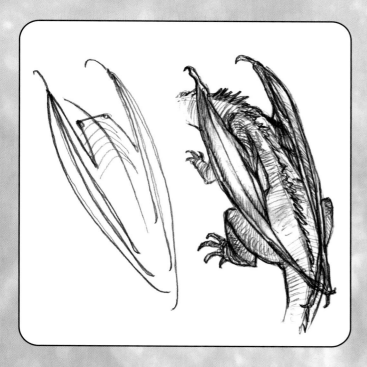

◄ When the dragon rests, its wings are tucked away, folded neatly against its body. Note that the fingers are drawn much closer together – almost touching – and that there is a gentle curve of the bones when they are seen from above. The webbing is folded in on itself in between the fingers.

The placement of the dragon's wing is very important when making your creature believable. As most land mammals tend to have only four limbs, the addition of two extra limbs can prove to be problematic. The usual placement is over the creature's forelimbs, extending from just above and behind the shoulder joints. If you study the dragon's skeleton on page 18 you can see how this is one way to solve the problem.

CLAWS & PAWS

A dinosaur's hands and feet can be hand-like, paw-like, foot-like or even hoof-like. Variety is the key when building your creatures, taking inspiration from all kinds of different animals. Four digits are usually the dragon standard, although there's no reason your invented character can't have more or less, so long as it looks believable.

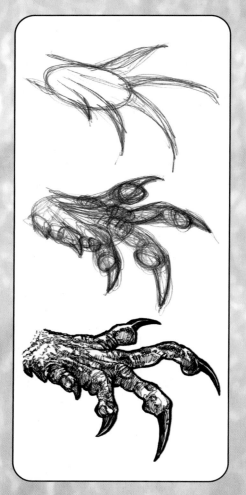 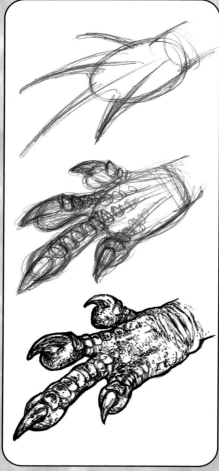 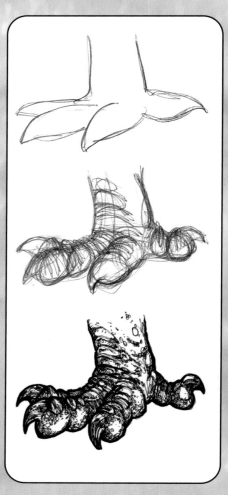

▲ The basic front claw starts with a flattened sphere which represents the palm. Draw gently arched lines which extend out from its centre for fingers. The longest finger tends to be in the middle, with two more digits on each side and another on the outside of the palm. You can also add a tiny 'dewclaw' approximately where a thumb might be. Build up the fingers into cylinders, with perhaps a sphere on the end of each finger.

Add sharp claws as fingernails and for added realism make sure that they are 'set in' to the finger rather than just a continuation of the digit.

▲ Here's a slightly different version of the clawed paw, which might be used on either the front foot or rear. You can flesh out these fingers (or toes) with small spheres to create a series of knobbly-looking digits. Some neat scaly embellishments to the tops of the fingers and wrinkles at the wrist add a certain gnarly charm to the paw.

▲ By altering the angle of the joint where the leg meets the foot you create something which is most definitely a hind limb. Note the way the toes overlap when seen from this angle. Build up the structure using small spheres, add talons and lots of surface detail and you have a beautifully ugly dragon foot.

TAILS

The thick, tapered snake-like appendage of the dragon's tail is one of its most distinctive characteristics. They can of course vary in thickness, length and skin coverings.

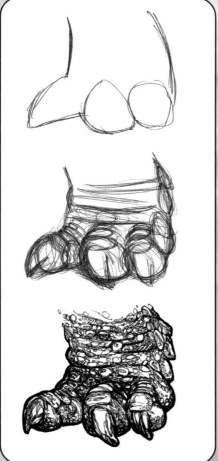

▲ This example almost does away with the foot entirely, simply adding three toes to a wide, thick leg, resembling that of an elephant or hippopotamus. Toes once again are constructed from spheres and the heavy skin sags around the ankle in folds, which also act as contour lines to describe the cylindrical shape of the leg.

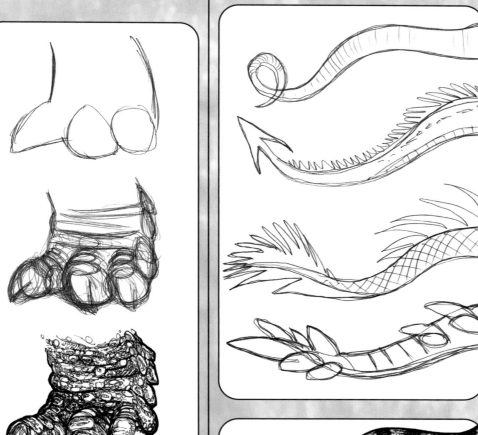

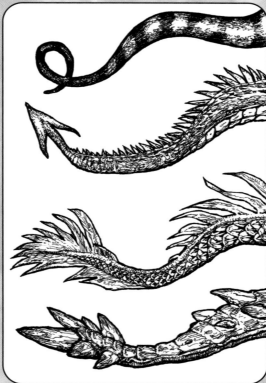

Always remember to start with a smooth curve, drawn swiftly to try to encapsulate the movement and life that a dragon's tail should always display. You may be able to recognize the influences on these tails from the animal kingdom, such as snakes, fish, lizards and armoured mammals. The two-stage examples here can be studied and copied but you can use almost any combination of shapes, sizes, skins, markings, scales, pebbles, barbs and spines to create your own. Often, a dragon's tail ends in a spade or barb but it could end in a little tuft of hair. Look to nature for inspiration. Remember to try to use the contour lines of the underlying tapered cylinder or cone shape as a basis for any skin markings or scales. This will give your tail convincing three-dimensional form.

SCALES, FEATHERS & FUR

Your decisions about which skin textures you choose to cover your fantasy creatures with, such as scales, feathers or fur, can drastically alter the appearance and character of your beast. So it's important to be able to render each of these texture types well.

Textures shouldn't be applied mechanically all over your creature's body. Varying the size of the scales and using different skin coverings like fur on different parts of the body will enhance your illustrations enormously.

▲ Wrinkled, leathery skin such as a rhinoceros hide can be created with short, random lines to suggest creases. Built up with lines of varying thickness, these lines can be used to create shadow and describe form.

▲ Studded scales can be created by first laying down a loose grid as shown here. Don't make your grid too regular, as you want it to look random and organic. Add small circles to fit in each diamond shape, overlapping slightly. Some shadow can be added on the underside (be careful to make the lighting direction consistent) and a snake-like skin texture should be the result.

▲ A more random, pebbly hide should also be created using some loose contour lines as a basis. An area of large and small irregularly shaped circles can be built up to create the desired effect. Shading on the underside of the larger pebbles aids the three-dimensional illusion.

▲ Overlapping snake-like or fish-like scales are again best laid out on a grid. By first wrapping the grid around the three-dimensional shape that you wish to render, you can confidently place each piece in its correct position and perspective.

▲ A more decorative alternative is the crocodile-style hard, scaly scutes. Again, the contour lines help you to lay out your scutes in accurate perspective. Note how the pattern tends to fade out towards the underside of the object.

▲ These scutes can also be applied along the neck of a dragon as seen in this example. Note that they are used sparingly along the top part, with wrinkles roughly following the contour lines around the lower part of the cylindrical neck.

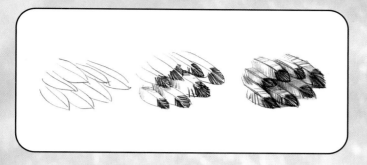

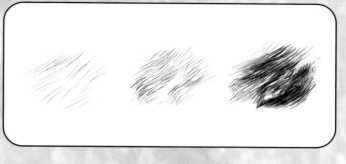

▲ Feathers are built up in overlapping layers. The addition of shading underneath the ends of the higher layer of feathers helps to separate them. Note the barbs of each feather extend out from the centre shaft upwards toward the tip. Don't try to draw every barb.

▲ Fur textures can be created using short overlapping strokes with slightly varied directions, building up some areas more heavily than others to indicate shadow and form. Fur, hair and feathers all soften the appearance of creatures, making them friendlier and more appealing.

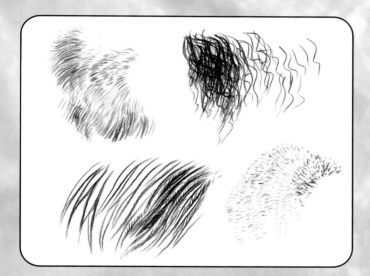

◄ Other textures can be created by varying the length, direction and frequency of your stroke. A lighter, silkier fur, tangled and matted hair, downy feathers and bristles can all be produced by practising different styles of rendering as shown here. It can take some effort and dedication to be able to portray convincing textures, so don't fret if you can't always get the effect that you are striving for immediately.

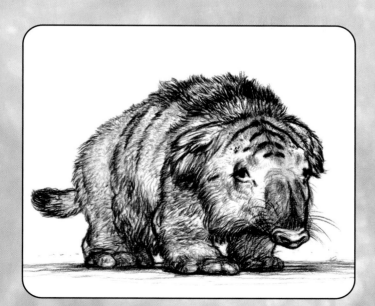

▲ This furry part-bear, part-pig, part-tiger hybrid creature demonstrates a beautifully rendered furry coat.

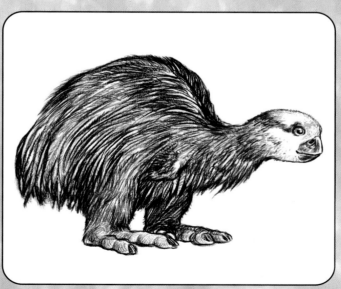

▲ This moa-like bird illustrates the use of long downy feathers as a body covering.

Drawing Dragons Step-by-Step

You have so far learned what sort of equipment to use, how to construct your dragon from simple blocks, how to pose your dragon and studied various aspects of the dragon's body from the head to its feet. Now at last it's time to create and render a whole dragon from start to finish.

CROUCHING DRAGON

This is quite a complex pose to achieve and so it's very important to get your proportions and stance exactly right before you move onto the next stage. Don't be in a rush to complete this stage of the process.

Now you may think that a stationary, seated dragon wouldn't really need an action line. Although it can be drawn without one, the action line can still provide life and elegance to your pose. Here, a curling line encapsulates the curved spine and spirals all the way round its tail. You could even visualize the top of the rock as a continuation of it, and the arc is echoed by the edge of the wings.

Essentially, the dragon is portrayed by a large egg shape for its body and the split cone of its head. Simple lines – always slightly curved – connect the head to the body and provide the basis for all the creature's limbs.

The dragon crouches on its four legs on another egg shape which will represent a large boulder. Indicate the position of the feet, which follow the gentle curve of the rock. Remember that the forelimbs bend backwards like elbows and rear limbs bend forwards like knees. It might even be useful to crouch on

the floor yourself to get a feel of the pose. The wings then connect directly above the forelimbs at the top of the ovoid. Again, the wings bend forward like extra arms. Sketch in the position of the three main 'fingers' for each wing.

Hopefully, you will have something which resembles the drawing here, nicely centred on the page. If not, start again: it's best not to waste time at this early stage trying to rescue a poor first effort. Starting afresh will be much easier.

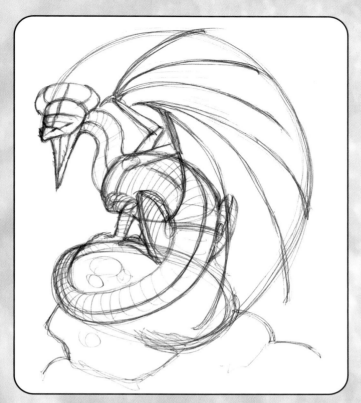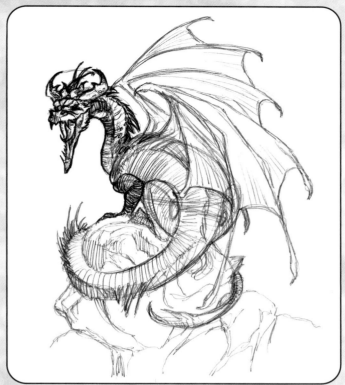

▲ Start to flesh out your wire framework with extended cylinders and cones, starting with the tightly curved yet still smoothly shaped neck and tail. Notice how the tail, curling all the way around the rock until it almost touches itself, tapers from almost the width of the body to a point at the end. Contour lines following the shape of the body parts will give you a feeling for the form and three-dimensionality of your beast. Flesh out the limbs and be aware of how much the dragon's torso is hiding. The rear right leg is represented by a thick thigh, with the shin being only partly visible.

Thicken up the arms of the wings. An arched guide line suggests the limit of the wings, helping to provide the composition with balance. Provide a little more detail to the head, developing the snout and adding horns. Your drawing should now be looking like a solid, three-dimensional creature, with weight bearing down on the boulder underneath it and ready for the application of surface detail.

Once you are an experienced and supremely confident illustrator, you may like to start to render your dragon in ink at this stage. Until then, you will want to make sure everything is in the right place in pencil before you start applying a permanent medium that is much more difficult to correct.

▲ Gently erasing the construction lines will give you a cleaner image to work with before adding further detail. You may even like to trace your messy construction drawing onto a fresh sheet of paper before continuing; if you are going to complete your image with inks or paints, it may be best to transfer your construction onto a heavier cartridge paper anyway. Be careful not to lose the immediacy and life of your original though.

Now you can start adding all the fun refinements, like the tail and neck spines, extra flourishes on the tail, head and horns, facial details, a pointed tongue and teeth. In fact, everything about this dragon is pretty pointy.

The dragon's left wing is overlapping both the right wing and part of its back. Don't be worried about part of your drawing being hidden by another part. Draw each wing carefully, paying attention to the creased skin stretched between each of its bony fingers. There are no shortcuts here, just hard drawing practice.

OK, so now you can start inking your drawing with the implement of your choice. It's normal to start with the most important part of your illustration, often the head. That way, if you mess up, you can start again with the least amount of wasted time. The head also tends to be the focal point of the whole image and in our example here, the wings and tail all curl around towards the head, leading the viewer's eye directly to it. The head is framed by white space too, so you really can't stop yourself from looking at it first.

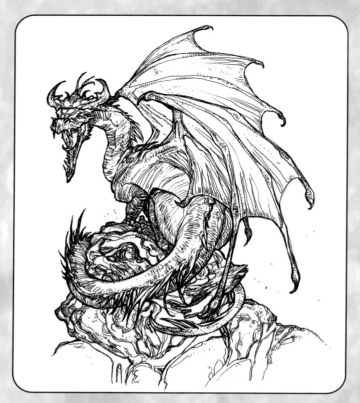

◄ Varying the weight of your ink line makes all the difference to the finished result. You have already seen how a thicker line can help to define the edges of your figures, helping to separate them from the background. Thicker lines on the underside of objects also suggest shadow. Thinner lines can then be used for adding surface texture and detail, like the wrinkles on the skin of the wings and the creases along the contour lines of the beast.

Those using a brush or a split-nib pen are able to vary their ink line by altering their pressure on the paper. If you are using a fixed-width pen or fineliner, you can switch between widths or build up the lines by multiple passes of your tool. Each method has its own characteristics, advantages and disadvantages, so don't be afraid to experiment until you find one that suits you.

Be careful not to over render. It is easy to get carried away and lose the freshness of your drawing in a mess of cross hatching. More is not always better.

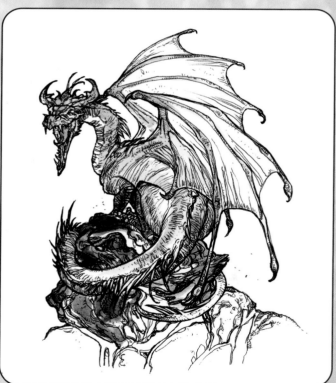

◄ Now you can add colour to your finished inked image. You may want to create a colour 'sketch' first, to try different approaches and experiment prior to laying down colour on your original. If you have a clean inked drawing to colour, you can even have it photocopied onto cartridge paper and colour that as a test run.

Lay down translucent inks or watercolours over the top of your inked line drawing. There's no need to be too precious as you are laying down a base which can be built up with successive layers of wash. Try to mix colour as you go, rather than laying down a single flat colour like a stained glass window. Leave areas of white to act as highlights, or to show through further layers.

Always mix colours, rather than using them straight out of the bottle or tube. This will help give you more realistic, earthy tones. Use darker, more saturated tones on the underside of objects like the dragon's belly where you imagine there may be shadow.

◄ By adding successive layers of translucent colour you can achieve subtle colour gradations. Colour swatches like this can help you work out a colour scheme for your illustration.

When using watercolours or inks, always work from light layers to dark. You can even enliven your image by applying colour pencil to strengthen some tones and opaque white paint (like gouache or 'white-out') to add highlights.

Your ferocious dragon is complete, warning off visitors to his volcanic rocky outcrop on the mountainside.

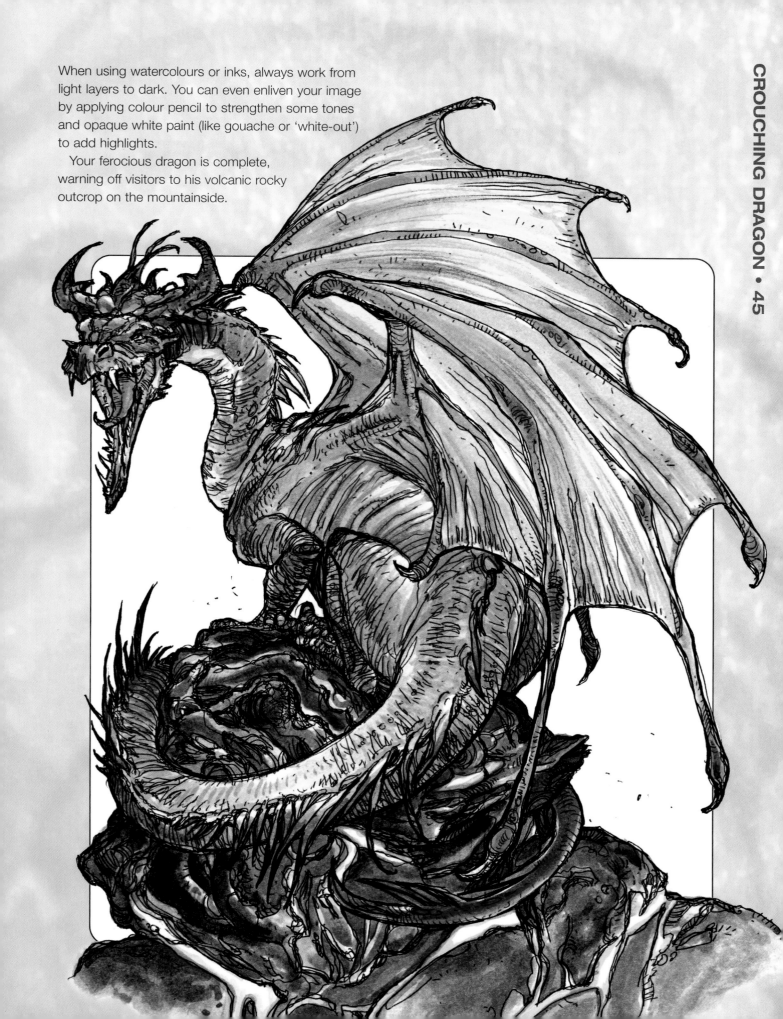

FLYING DRAGON

Now you can move on to something a little more sophisticated like a flying dragon. This will be a little different, as the creature will be swooping towards you. There will be some foreshortening to the figure, making the dragon's head (closest to your point of view) appear much larger in comparison to the rest of its body, tapering off into the distance.

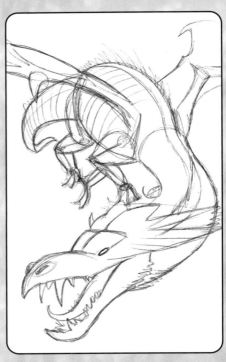

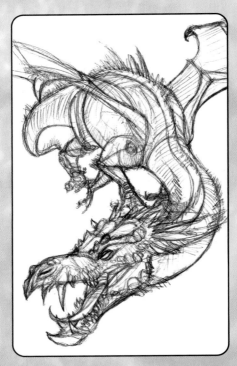

▲ Start off by drawing an action line, encapsulating the energy and the movement of the whole figure in one sweep of your pencil. Onto this centre spine of the creature, you can add the ovoid shapes of the head and torso and the thick, snake-like curved cylinder shapes of its neck and tail.

The dragon's snout, open aggressively as it flies down to attack, resembles the savage beak of a bird of prey, and with its horns and fins lying flat behind its head it really gives the impression of speed and direction.

On the torso itself, you should indicate where the wings will start with a simple slightly curved line, a short distance behind the neck; visualize them sprouting from its narrow shoulders, at ninety degrees away from its body.

▲ Once you are satisfied that your basic pose and proportions are correct, you can proceed to add further details, like the short, tapered cylinders of its legs and its large bat-like wings, refining your construction lines until you 'find' the right line.

Contour lines around the torso and tail help you visualize its form and place its limbs in the correct position. The left forearm is almost entirely hidden, but just the suggestion of the claw to which it is attached helps balance the figure.

Adding details like the raised areas around the creature's nostrils can help to make your fantasy creature come alive. A long pair of fangs, pointed teeth, a curling tongue, small fins, spiny protrusions and nasty claws all go towards making the dragon look suitably ferocious.

▲ Now you can start adding in all the fine detail, a small, squinting eye with lids, lumps, bumps, spines and spiky horns all over its head. You can raise the dragon's spine by drawing a line parallel on either side of its fins, running down the length of its back. Its leathery wings are stretched between its bony fingers.

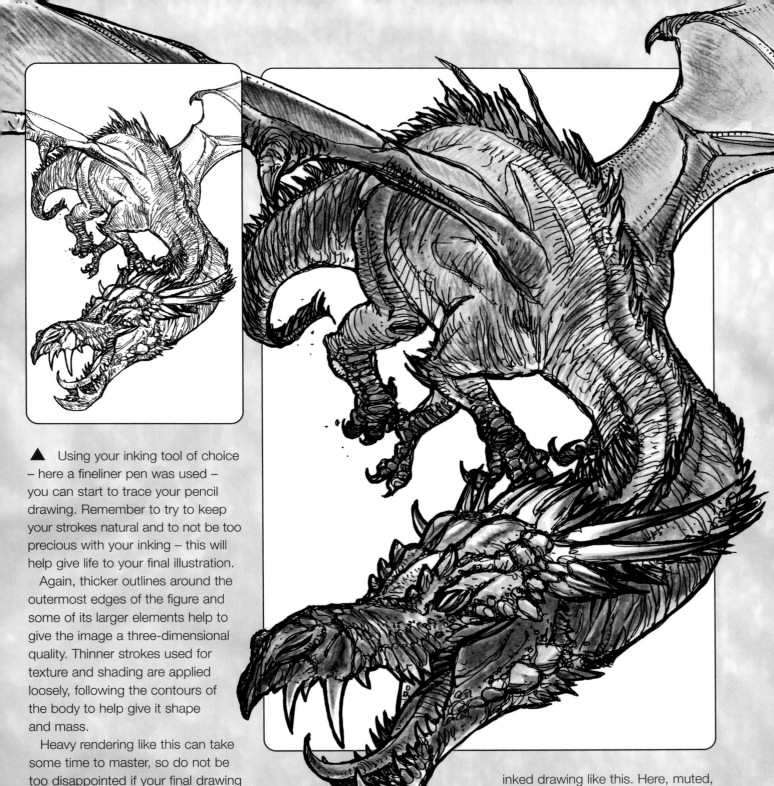

▲ Using your inking tool of choice – here a fineliner pen was used – you can start to trace your pencil drawing. Remember to try to keep your strokes natural and to not be too precious with your inking – this will help give life to your final illustration.

Again, thicker outlines around the outermost edges of the figure and some of its larger elements help to give the image a three-dimensional quality. Thinner strokes used for texture and shading are applied loosely, following the contours of the body to help give it shape and mass.

Heavy rendering like this can take some time to master, so do not be too disappointed if your final drawing does not look perfect. But analyze what you think is wrong with your drawing, then try again – it's practice, practice, practice that's required!

▲ If you wish to colour your swooping dragon, a limited palette can give a simple yet surprisingly satisfying effect. Watercolour washes and coloured pencils are quick and easy methods to use over a finished

inked drawing like this. Here, muted, earthy tones of green, with a little red for detail is all the colour this angry dragon needs.

Applying colour in an organic way, rather than using flat colours can give a much more natural effect. Remember to leave areas of white to act as highlights, rather than swamping every tiny part of your dragon with colour.

BABY DRAGON

And now for something a little cuddlier. A cute, little, sweet innocent baby dragon.

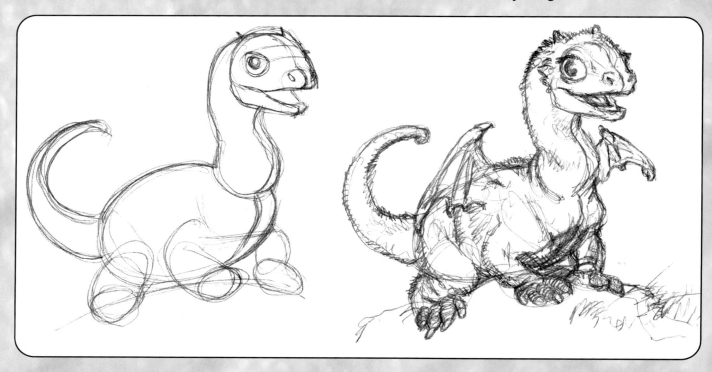

▲ For adorable, infant-like characters, always try to use short, stunted and more rounded forms. The large head in comparison to its body size, the short snout and the domed forehead enhance the cuteness of the animal.

Large, appealing eyes are also a must. Short fat limbs, tail and neck coupled with its stumpy horns all add to its youthful appearance. Its tiny wings are not ready to carry it skywards just yet.

► This has been finished in coloured pencil, particularly suitable for rendering the baby's short downy fur. Note that areas of white still show through and darker shadows have been built up into areas of deeper tones, creating shape and form. The slight bagginess of its skin, especially around the claws, knees and elbows, suggests that this little sweetheart still has some growing to do. The white highlight on its eye brings an innocence and brightness to this loveable character.

You may like to use some of the softening characteristics of this baby dragon in the creation of a friendlier adult creature – such as big eyes, long lashes, fur and definitely no sharp teeth, fins or horns!

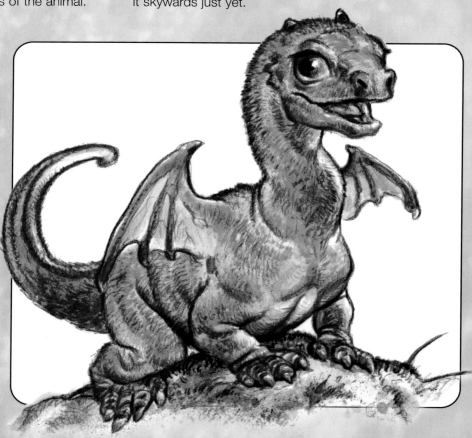

DRAGONFLY DRAGON

Here's a completely different way to approach your drawing. This dragon, inspired by a dragonfly, has been designed and rendered by using a graphical method rather than drawn in a realistic, illustrative way.

▲ Design is the key in the initial pencil layout. The tail and spine form almost a complete oval, neatly encompassing the body and limbs of the creature. The wings spray out from the outside of the oval shape and the neck deliberately protrudes beyond the oval, drawing the viewer's eye to the head.

▲ In this drawing the emphasis is on clean, clinical lines, creating a strong, graphical design in flat profile, like a tattoo or a logo. Small, decorative patterns can be added to the body and wings but the details should all be neat and regular, rather than organically applied.

► The use of a colour palette limited to reds and browns ensures a compact and effective design is retained. Despite the flat, graphical nature of the image, colour can still create a three-dimensional effect by the use of different levels of colour intensity and particularly the areas left as white, creating bright highlights. Study the colour application on the neck to see how the shiny texture and cylindrical effect has been achieved.

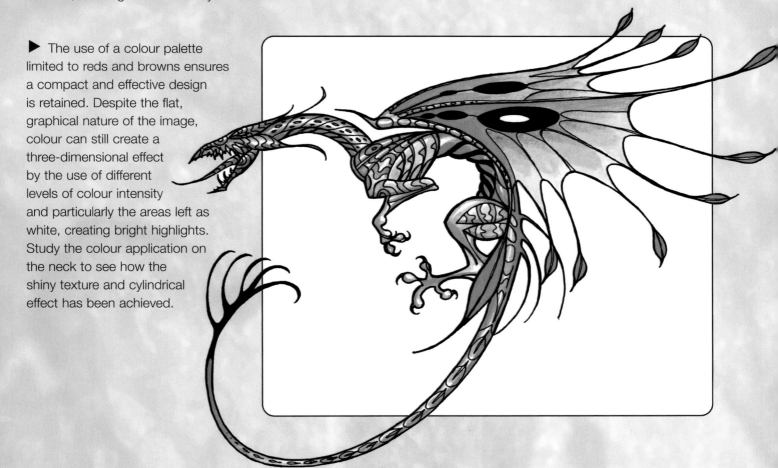

TREASURE CAVE DRAGON

Avid readers of fantasy literature will be familiar with the concept of treasure-hoarding dragons, guarding their ill-gotten gains from all comers.

► This slim and elegant dragon is secure in the knowledge that he can repel any raiders and is therefore very comfortable just sleeping draped over his treasures.

As his body is resting on a large mound, his neck arcs downwards and his forelimbs and wings are relaxed. Always try to simplify, breaking down your creature into the minimum number of elements, represented by simple shapes. Look how the egg shape of the dragon's torso is slightly fatter at the bottom, the effect of gravity on the weight of the creature's flesh which slumps down onto his treasure trove.

Gently distorted cylinders form his forearms and his neck, and a cone shape is sketched in for his head. The dragon's wing position will be most difficult element to visualize. Remember that it's best to draw the

bones of the wing's 'arms' first, sprouting from its imaginary shoulder blades, jointed in the middle and with fingers extending down to the floor.

The beast's left wing is the most interesting as the viewer can see parts of both the inside and the outside of the wing.

► Once you are happy with the proportions, perspective and position of your sleeping dragon, you can start to refine the outlines, add some major details and indicate shape with contour lines. Keep working your pencil to find the 'right' line and don't be afraid to erase or even start over. Carve out details from the dragon's head like his mouth, a bulbous snout and forehead. Add eyes, horns and fins all along the ridge of his spine, develop the claws and figure out exactly how the wings are arranged. You can also sketch in the suggestion of a background. A few simple lines suggest the wooden supports of a disused mine, instantly creating atmosphere and intrigue.

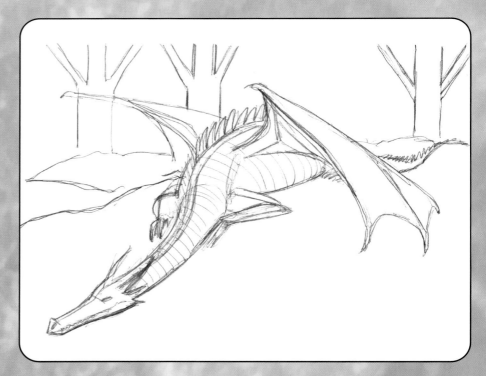

► You can build up the drawing into a finished pencil illustration by cross hatching and shading the dragon's body, generally following the shape laid down by your contour lines. This example has been rendered in a loose, scribbly style.

A suggestion of steam or smoke has been indicated by a faint outline and erasing parts of the background but leaving some to still show through.

Shadows have been created behind the mine's roof supports and the hoarded treasure has been indicated by just a few suggestions of small objects and bones of dead treasure raiders. There is no need to draw in every jewel or gold scabbard.

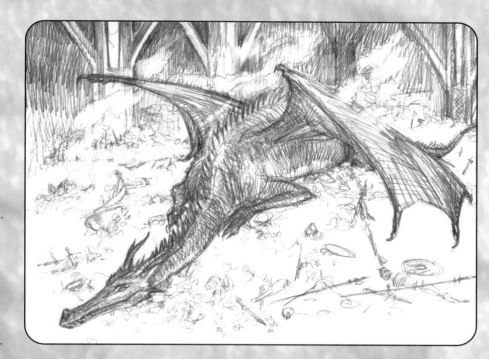

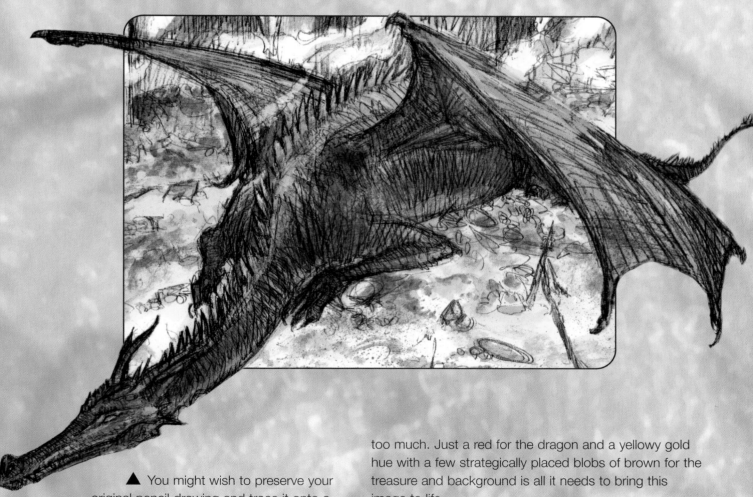

▲ You might wish to preserve your original pencil drawing and trace it onto a new sheet to ink and colour it. If you are brave, you can place a wash of colour right over the top of your pencils. Keep the colours simple to avoid muddying up the image too much. Just a red for the dragon and a yellowy gold hue with a few strategically placed blobs of brown for the treasure and background is all it needs to bring this image to life.

You can even add black pen and ink details over the top of your coloured image to enhance parts of the image or to increase the density of the shadows.

CHINESE DRAGON

A Chinese dragon is very different from a Western dragon. It is used in graphic designs a great deal and the image is rather more like a print than it is illustrative, so accurate anatomy is less important than the overall impression.

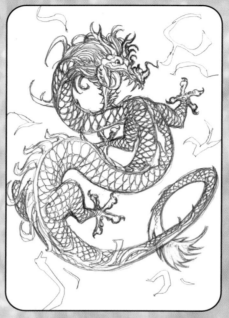

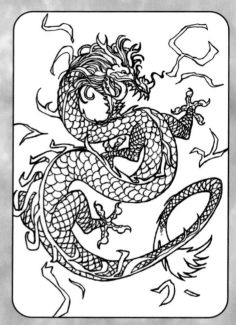

▲ The Chinese dragon has a very long, slender and flexible snake-like body which tends to bend itself into a convoluted shape. Considering your action line, the creature's spine, is very important here.

Build your initial line up into a long cylinder or tube. The thickness of the body remains fairly constant, except for a tapering towards the tail. The tail will actually end in a flourish and the head shape is again very snake-like. Accurately indicating contour lines around the body shape will prove important when adding the beast's scales. It may help to think about it as a tube being sliced up into regular segments.

Placement of the arms and legs is also more difficult, as you have no ovoid torso to attach them to. Try to place each of them at about a third of the way from the head and the tail. In terms of design, note how the limbs are arranged to fit pleasingly into the white space.

▲ This is the point where the real drawing starts, refining and supplementing your basic layout, and adding details, frills and design elements. The limbs and torso are worked up into a more body-like shape. The Chinese dragon has fearsome teeth, an impressive shock of shaggy head fur, overlapping scales the length of his body, chicken-like claws, soft spinal fins and a furry tail end. You can also add a decorative 'crackle' around the beast to signify its energy.

▲ Because of the graphic style of the character design, you may like to render this in a more mechanical way, inking with a fixed width pen like a fineliner. This makes it look a little like a label on a brand of Chinese food. You can of course choose to render your dragon in a looser, more realistic manner for an entirely different effect. But varying your technique helps you to broaden your artistic abilities, rather than relying on one single style.

Here, thick, bold lines have been used, ignoring many of the smaller pencilled details, to give a bright, fresh, clean image.

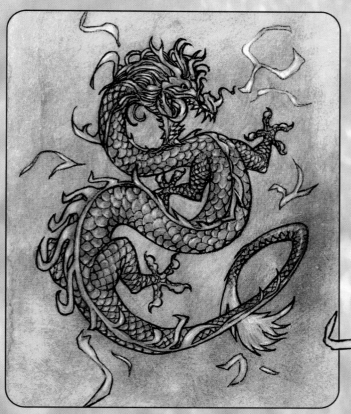

◀ When adding colour, sometimes it's nice to have a coloured background on which to work. You can use coloured art papers, or you can use a coloured wash over your whole image at the initial stage. You don't even need to use paints or inks. Here, in order to create an authentic, antique parchment effect, the paper was briefly stained with the remains of a cup of coffee and then rubbed with loose earth from the garden. This method is not necessarily essential for every piece you may wish to create, but shows how lateral thinking and experimentation should always be part of the artist's canon.

White highlights can be pulled out from the colour base with a chinagraph pencil or pastel, or you can use an opaque paint like gouache or acrylic.

▶ A vivid green wash can be applied if you wish to complete the picture in full colour. With some pink applied to the dragon's horns and tongue and gold for the 'crackle', its fur and fins, this simple colour scheme makes a very effective final image.

Further white highlights can be added to complete the picture.

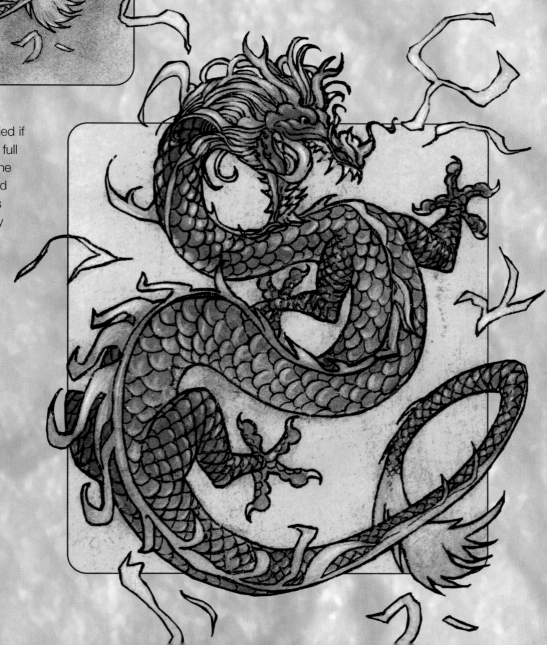

THE WYVERN

Those unfamiliar with dragon lore may wonder what the difference is between a dragon and a wyvern. After all, they do look pretty similar. Visually, the most obvious thing is its lack of forelimbs – all wyverns have just two legs and two wings. It is possible though to create a dragon which has no forelimbs, but which is still a dragon. Wyverns have other distinguishing traits though: they do not breathe fire and are usually baser, nastier and less intelligent.

▶ As the wyvern has only two legs, care must be taken to balance the creature so that it looks stable. The legs are attached towards the centre of its short fat body and the thick limbs terminate in wide flat feet. A similarly thick neck and tail extend from the body, while the wings stem from the usual shoulder area. In this three-quarter view, the wyvern's right wing is partially hidden, but your underdrawing will assist you to place it correctly. Heavy mass, compactness and power, as signified by its coiled tail, should all be apparent in your drawing. The head is very much based on that of a snake, with some additional spines jutting away from the back of its head.

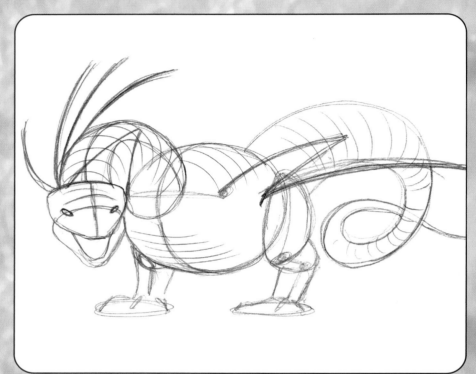

The final image has been heavily rendered in ink, with large pools of shadow underneath the body, helping it to jump off the page. The lighter rendering on the creature's back, particularly on the spine, further suggests that the light is falling from directly above the beast. Once again, the skin texture is indicated with wrinkles that roughly follow the contours of the shape of the body and limbs.

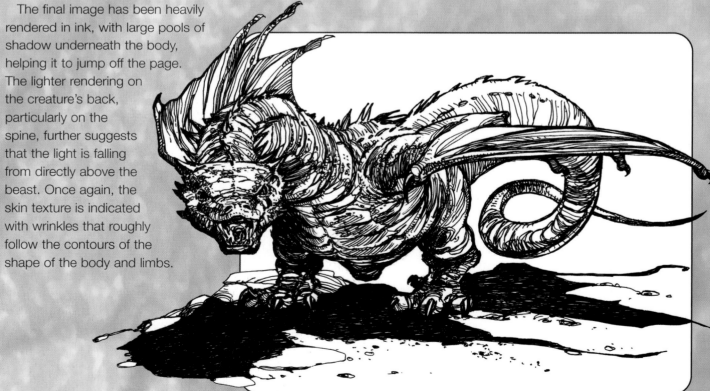

THE HYDRA

The Hydra is not really a dragon either but its reptile-like qualities warranted its inclusion in this chapter. This charming character has the body of a dragon, or even a dinosaur, minus the wings but with multiple snake-like heads. Famously, if one of the monster's heads were to be chopped off, two more would take its place.

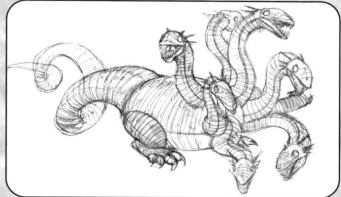

▲ Start by drawing the usual ovoid for its body, with a thick coiled tail, supported by short, powerful legs. Notice the size of the oval for the foot is almost as large as the thigh. Now, instead of one curved line to represent a neck, we have eight, all of which terminate in an oval. While each neck is the same length, the effect of foreshortening means that your neck lines will all be different. Try to be creative in the placement of the heads, have them looking in different directions, but remember to keep a balanced, pleasing composition.

▲ Flesh out the necks and tail as curved cylinders, draw in your contour lines and try drawing in the evil-looking, many-toothed, blank-eyed heads. Note how each one here is drawn from a different aspect.

▼ The final image here has been transferred onto grey art paper, inked and coloured with oil pastels. Using specialist papers can have a dramatic effect on your final image. The pastels, lightly applied, pick up the rough texture of the paper. Pastels can be smudged into each other creating a smooth gradation of tone. Lighter hues are layered over the darker hues and white highlights add drama. Finally, the inked outlines are strengthened. You could also use coloured pencils or even artist's crayons to create similar effects.

Horse Hybrids

There is much more to the world of fantasy beasts than just dragons and their cousins. Fantasy literature is rich in all manner of fabulous creatures, some of which you will learn how to draw over the following pages. To start, here is a selection of creatures based on horses which have been combined with other animals.

DRAWING THE HORSE

▶ All major living creatures are difficult to draw. They all have joints which hinge and twist, muscles which flex, contract and expand and movement which is a huge challenge to encapsulate in a two dimensional drawing. The horse is just about the most difficult.

In order to create convincing, believable fantasy creatures, they should be grounded in reality. To draw a part-man, part-horse creature like the centaur for example, the artist needs to be aware of both human and equine anatomy.

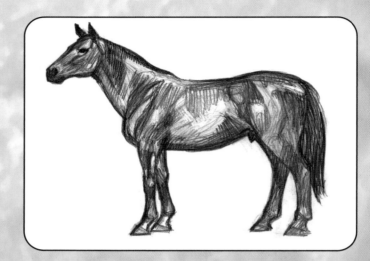

▶ The horse's skeleton shares the same major parts as many other animals, including humans: skull, neck, spine, rib cage and limbs – legs and arms or wings. As you have seen earlier in this book, even the characteristics of the way elbows, knees, wrist and ankles move are very common in the animal kingdom, so building hybrid creatures by combining skeletal parts is an excellent starting point.

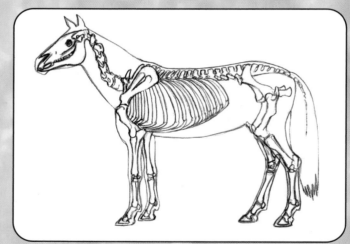

▶ Of course, you don't need to draw the whole skeleton in great detail but an understanding of it and the way it works helps you to draw your blocks and shapes in the correct position and proportions.

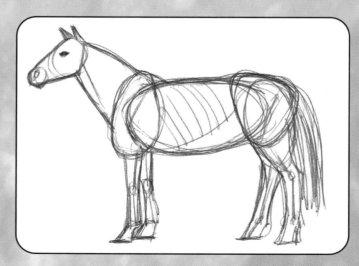

PEGASUS

The winged horse Pegasus is a creature from Greek mythology, who sprung to life after the hero Perseus chopped off the gorgon Medusa's head.

▶ Physically, Pegasus is essentially a horse with large feathered wings. In the same way that you have learned to incorporate bat's wings onto a reptile in order to create a dragon, the bird's wings should attach to the horse in the vicinity of its shoulder blades.

The construction of the horse should be constructed as on the previous page, from ovoids, lines and cones.

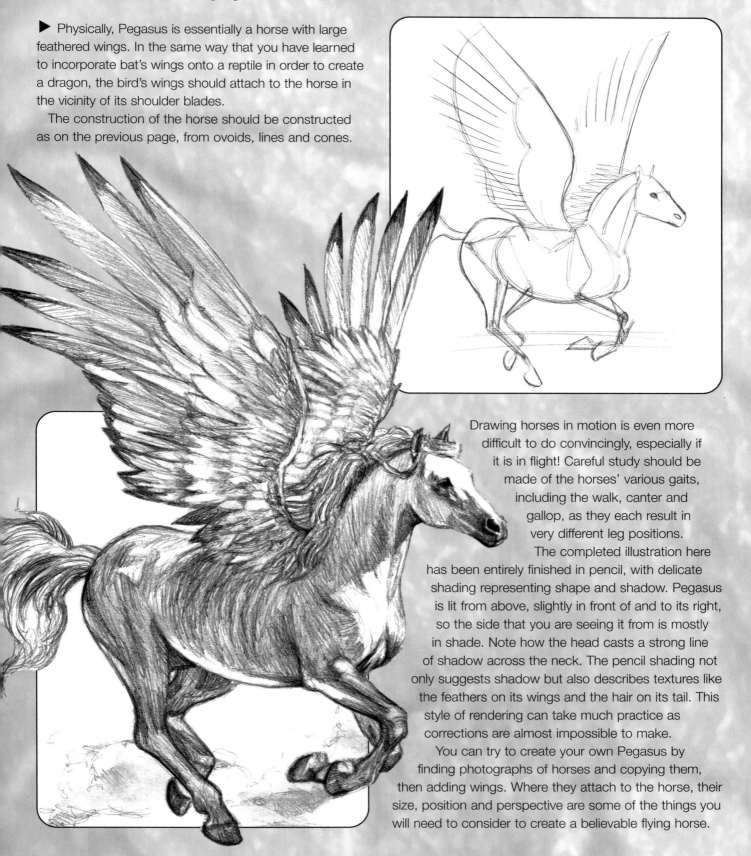

Drawing horses in motion is even more difficult to do convincingly, especially if it is in flight! Careful study should be made of the horses' various gaits, including the walk, canter and gallop, as they each result in very different leg positions.

The completed illustration here has been entirely finished in pencil, with delicate shading representing shape and shadow. Pegasus is lit from above, slightly in front of and to its right, so the side that you are seeing it from is mostly in shade. Note how the head casts a strong line of shadow across the neck. The pencil shading not only suggests shadow but also describes textures like the feathers on its wings and the hair on its tail. This style of rendering can take much practice as corrections are almost impossible to make.

You can try to create your own Pegasus by finding photographs of horses and copying them, then adding wings. Where they attach to the horse, their size, position and perspective are some of the things you will need to consider to create a believable flying horse.

THE UNICORN

Famously, the unicorn is a beautiful, predominantly white horse with a long spiralled horn protruding from the middle of its forehead. It is one of the most renowned mythical creatures with stories emanating from as long ago as 400 B.C. Ancient Greeks actually believed it existed in India but we now know it to be a creature of fantasy.

▶ Unicorns are essentially horses with horns and, since horses are hard to draw, it's best to start with a simple profile view. Getting the proportions exactly right is not easy, so be patient if it doesn't turn out so well the first time.

Start with a slightly arched spine with four legs extending from it. Again, there appears to be an additional joint in the unicorn's legs but what seems to be the knee is in fact the ankle or wrist. The knees (or elbows) are actually much closer to the body than you might expect. The big clue here is the direction in which the joints bend.

Approximately speaking, each of the three bones in each of the unicorn's legs are a similar length.

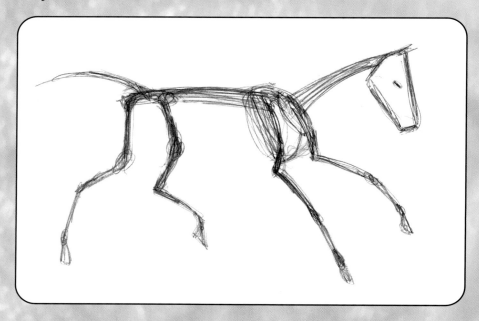

Rough in a line for the neck that terminates in a blunted cone shape for the head. Do not forget the tail, which curves upwards and out from the beast's rear end.

▶ Now start to flesh out the bones with shapes that will represent the unicorn's muscle mass. Note how the bulk of the ovoid-shaped torso extends almost down to the level of the first major joint of the leg. The hind legs are characterized by powerful muscled thighs, in strong contrast to the lower parts of the legs, which carry very little flesh. In the forelegs, the top part carries a little muscle but the lower parts are again thin. The joints of the legs are always very visible through the animal's skin and each leg terminates in a triangle which represents a hoof.

The wide neck tapers up to the head in a gentle arc and you can then sketch in the suggestion of a flowing mane. Develop the skull

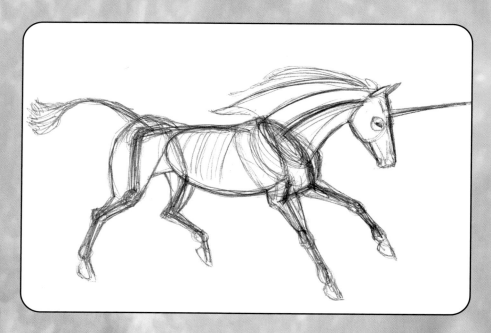

shape by indicating the snout and powerful jaw muscles. Add ears and an eye, with the unicorn's trademark horn, a slim tapered cone, extending out at right angles from just above the eye. Smooth the shape of the tail which ends in an appealing frond.

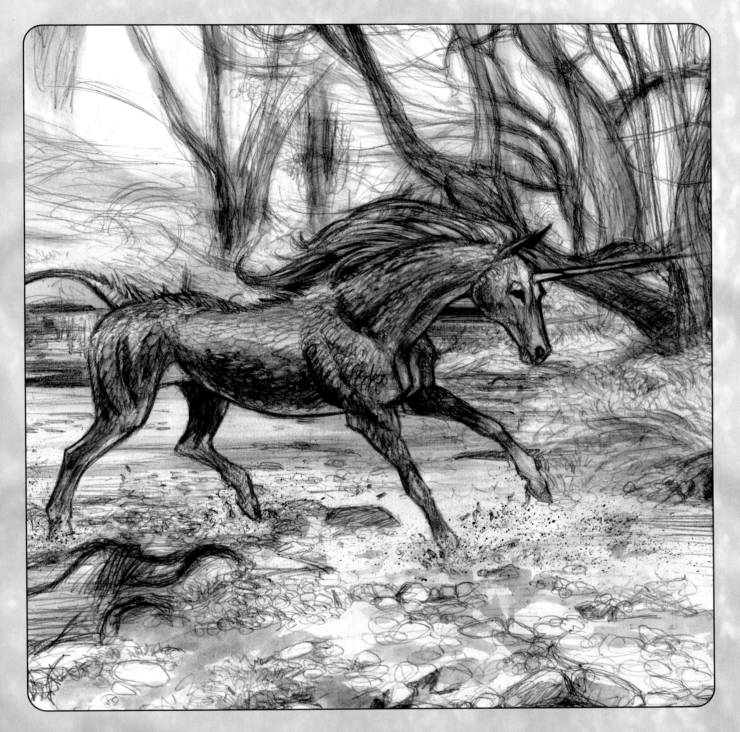

▲ Now you can clean up your pencil construction lines, or if you prefer you can trace your outlines onto a new sheet in order to apply your final rendering. This piece was finished on a watercolour board in regular graphite pencil, with some blue pencil highlights and a very light brown wash.

The unicorn's textured coat and shadows were built up using pencil shading and the splashing effect at its hooves helps to add movement to the picture. By using a firmer pressure with a soft pencil, a subtle outline helps to pop the unicorn out from the background.

The setting is almost as important as the unicorn itself. Typically, the creatures are found in enchanted forests and other fairytale locations. The trees, grass and rocks, built up with repeated thin lines create an atmospheric, ethereal quality. As we've said before, it's not always necessary to finish drawing every little rock in great detail, sometimes just the impression is enough. For this kind of panoramic picture, it is probably best to plan out your background separately and then combine it with your figure work at the final stage.

THE HIPPOGRIFF

A less familiar fantasy creature is the hippogriff. This is not simply a horse with attachments, but a curious hybrid of horse and eagle, the offspring of a horse and the mythical griffon. You will also learn to draw a griffon later on in this book (see page 70).

▶ The hippogriff has the head and beak, forelegs and wings of an eagle but the rest of the body – the neck, torso, hind legs and tail – is that of a horse. Of course, the eagle parts have to be scaled up in size to 'fit' the horse body.

In constructing the beast from shapes, it is best to start with the basic framework of the horse and adapt the other parts from there. Take a simple profile or side view for starters. Replace the characteristic horse's head with a simpler oval and beak, modify the front legs into claws and add bird's wings as you did with Pegasus.

The final rendering – again, here done in pencil – is all important. Where the parts of the two creatures are joined, a transition from feathers to hair should be carefully blended. The neck and the top of the thigh are heavily feathered and attention should be paid to the scaly texture of its eagle claws. The tail has been increased in size and the texture of it appears more like downy feather than hair, visually pulling the creature together.

Its gait is based on a horse's but the claws in place of the forelegs help to make it a convincing, yet fantastic illustration. A further challenge might be for you to try to draw a hippogriff in flight.

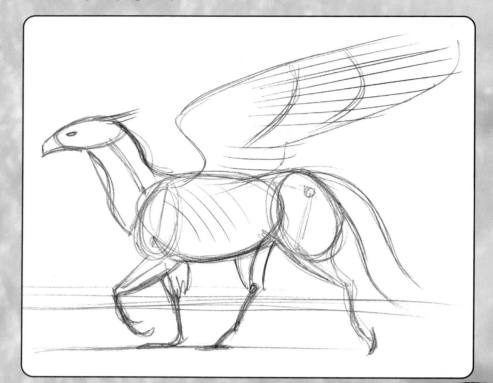

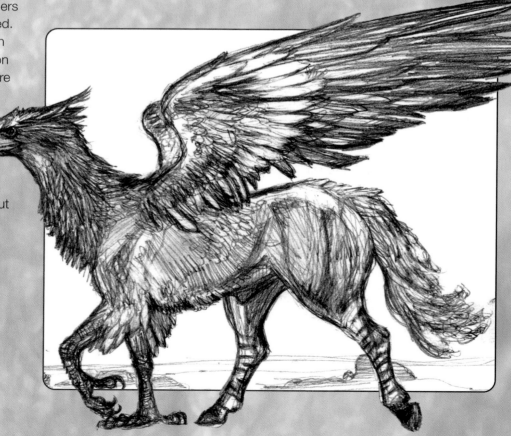

THE CENTAUR ARCHER

The centaur is the fabled half-man, half-horse creature with a varied mythological history. They are usually depicted as warlike, macho creatures, often used to represent untamed Nature.

▶ Here, the centaur archer is surveying the landscape, bow in hand, quiver full of arrows ready for his next attack.

The human figure transforms into the horse at the base of the horse's neck, which becomes the human's waist. The horse's forelimbs become the man's legs, albeit a little stumpier than a human's would be. The basic pose is static but the right foreleg is bent, perhaps preparing for action. Our view is slightly from underneath, looking up at the figure, giving the centaur a dramatic and proud air. Note how the three-quarter view is almost all of the left of the creature's torso as it is rotated away from the onlooker.

This image has been rendered in another technique, using coloured marker pens for outlines and shadow with additional tones applied using coloured pencil. Notice that there is no black used – a dark brown for heavy shading and the centaur's tail and beard and most of the outline in a mid brown colour. Brown marker is also used here to 'block out' areas of dark shadow. The effect is dynamic and graphic but also still realistic.

You will be able to study the centaur, especially the human part, in further detail later on (see pages 64–65).

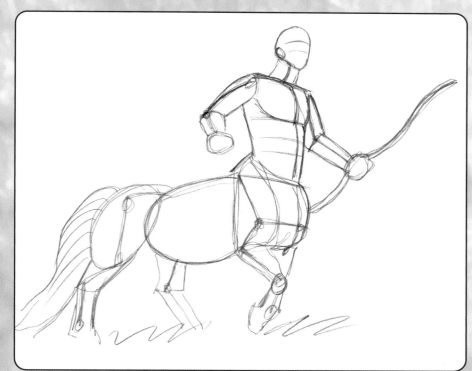

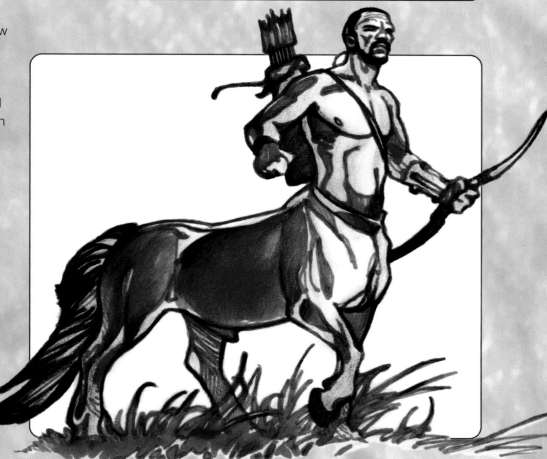

Human Hybrids
DRAWING THE HUMAN

A book on dragons and fantasy creatures can hardly begin to cover the vast subject of human anatomy, and the serious artist will already have an interest in it. But here is a brief introduction.

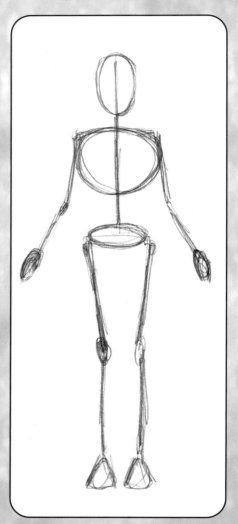 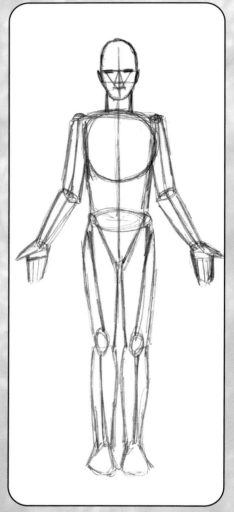 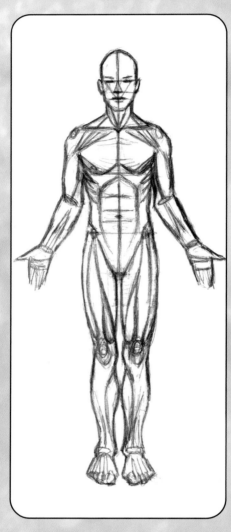

▲ Just as you have learned with your fantasy creatures, the human figure can be simplified into a stick man with egg shapes for its head, chest and hips. A centre line acts as the spine, with other lines for arms and legs. Another couple of shapes represent its hands and feet. By simplifying human shape and proportion, it becomes much easier to figure out poses and perspectives prior to fleshing them out into finished drawings.

▲ You can build up the stick figure with cylinders as you have done with your other creatures. The average human is about seven heads high. The upper body is about two and the legs are about four heads high. With the arms relaxed, the hands come halfway up the thigh.

▲ Musculature is an important part of anatomy and can greatly aid the serious artist when posing heroic figures or incorporating parts of them into fantasy creatures such as those described in this chapter.

THE SATYR

A satyr is a rather creepy combination of human and goat. The upper part – head, arms and torso – is mostly man, while beneath the waist it is all goat, complete with cloven hooves. Pointed ears, short horns, beard and ample body hair are also strong characteristics. This creature is linked to the Greek god Pan, as well as the fauns from Roman mythology. With his horns, tail and cloven hooves he can appear quite devilish. Here, however, a friendlier version of a satyr is depicted, seated on a rock and playing his pipes.

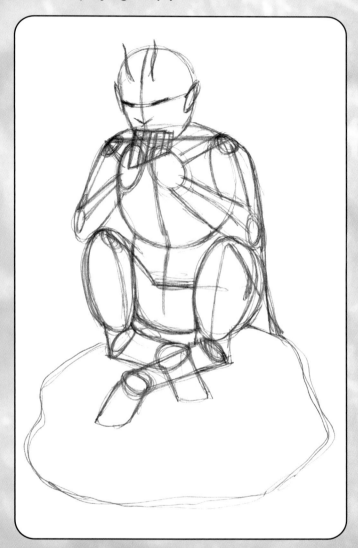

▲ Start with a human stick figure and flesh it out with ovoid shapes and cylinders. The seated pose is interesting and quite how the rear end of a goat would sit may require some visualization. The centre guide lines aid placement of the eyes, nose and chest muscles. Leaning forward for balance, the chest and pelvic region create a visible waistline. The neck is hidden by the forward position of the head. Cylinders form the lower leg and hooves of the satyr, while its arms rest on its knees as it brings its pipes to its mouth. The thighs are foreshortened and almost entirely hidden by the lower legs.

▲ The completed image is finished in pencil on textured paper. Stronger lines are used for the outline of the satyr and fur and hair is applied to the appropriate areas. Dark, unfeeling eyes and a short cape add a certain sinister air. Gentle shading in the background brings out the texture of the paper, and creates a little more atmosphere.

THE CENTAUR WARRIOR

As you have already seen with the centaur archer on page 61, this mythological creature isn't easy to depict convincingly, as individually the horse and the human forms are probably the most difficult to draw of all. Getting the parts to work together is even harder.

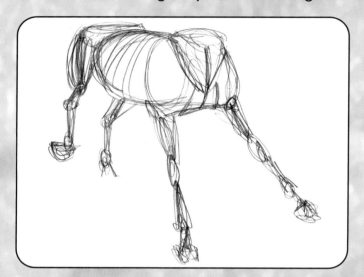

▲ You might like to consider each part separately. The horse components of the centaur consist of all but its head and neck, with the human's torso in place of the thick equine neck. These sketches have been built up over the basic shapes by a scribbling technique. If you have a clear visualization of what you want to draw, this can be a very intuitive and fun way of building up figures.

▲ Consider different poses for the human half of your centaur. Using tracing paper, you can experiment with different combinations of human and equine poses until you find a satisfying arrangement.

This warrior centaur will carry a shield and sword as he charges into battle. You can experiment with different placements of weapon to create a pleasing composition.

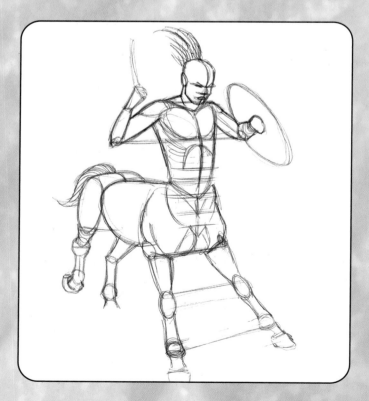

◄ If you wish, you can transfer your tracings onto a new sheet of paper once you have finalized the pose of your creature.

The view here is a little above eye level and from a three-quarter angle. This forces a little foreshortening on the centaur's body as it recedes away from the viewer.

The human half's hips are seated within, or in place of, the base of the horse's neck at about the position of the shoulders. You will want to avoid the look of a pantomime horse, by accentuating the fact that the forelimbs are equine and not human.

The leg joints are very visible through the skin, because of the lack of muscle and fat. Ovoids, which represent the knees, 'elbows', ankles and 'wrists', are each joined together with tapered cylinders and then terminate in a hoof. Remember that the meaty, powerful hind thighs will also form the creature's buttocks. From this angle, you can see only a small part of the tail. You can also place some initial markings for the face, chest and torso at this stage, bearing in mind the contour lines of the shapes.

◀ Refine your outlines and start to apply contour lines to give your figure depth and shape.

The two parts of the figure should be becoming more integrated. If they don't look right now, no amount of fancy rendering or dark shadows will help, so you may need to go back to the tracing paper.

The human face is another challenge that can take some time to master. From the angle you are looking, the head is tilted downwards and most of its left side is hidden. The eyes should be placed approximately halfway down the head. You can add flourishes like the centaur's pointed ears and long, mane-like hair all scraped back, helping to incorporate the human part into the horse.Develop the musculature of the human half – the chest, ribs and 'six-pack' abdominals all show through the skin. Biceps and triceps flex on the upper arm.

▶ This piece has been rendered entirely in pencil, by using subtle variations in shading techniques and a slightly darker, heavier line to accentuate the centaur's outline. The human half's torso is blended into the horse half's body. Textures like the horse's coat and chest hair are added, as well as some blood on the sword.

The centaur is an extremely unusual hybrid creature as it effectively has two torsos. You may wonder exactly where the internal organs like the heart, lungs and stomach are situated, or whether in fact it has two of everything. But try not to worry: this is fantasy, where everything is possible.

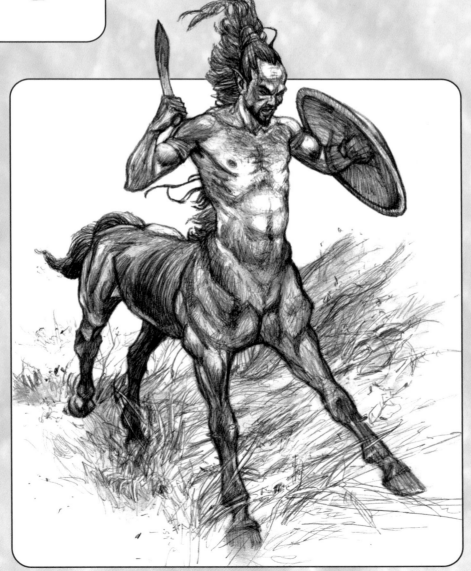

MINOTAUR

The Minotaur is another being from Greek mythology and is a rather menacing mixture of a man crossed with a bull. Confined by King Minos to spend his days hidden in a labyrinth consuming human flesh, he was finally slain by the hero Theseus.

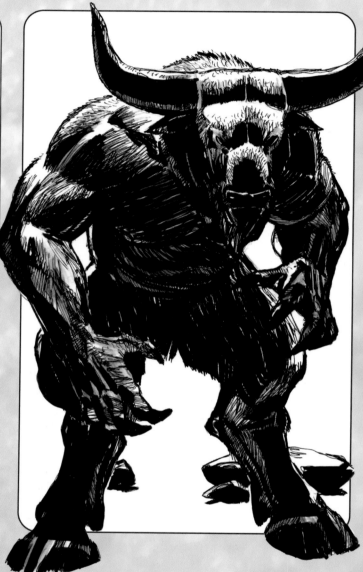

▲ A heavy-set human body that carries a bull's head and stands on two legs with hooves, the Minotaur is a smoothly integrated hybrid. With human thighs which transform into a bull's hind legs at the knees, large clawed hands and a thick neck which carries the bull's head complete with horns, this is a powerful and fearsome creature.

Start with the egg-shaped body and notice how the beast's posture is stooping and how the head is positioned in front of the shoulders rather than on top of them.

The limbs need to be similarly heavy and as thick-set as the rest of the body, with the arms appearing to almost touch the ground like an ape's. The legs are very wide apart, balancing on wide round hooves.

As the figure is rotated away from the viewer slightly, drawing in the centre lines helps to place the symmetrical components of the head as well as all the muscles of the torso.

▲ This frightening monster has been rendered in heavy shadow, using black and grey markers. Almost silhouetted against the bright light from above and slightly behind the creature, this Minotaur has been expertly inked with bold pools of black shadow. Short strokes of your inking tool will create the impression of a body covered in fur.

Note the contrasting areas left white to suggest strong light, creating a very dramatic effect.

THE MANTICORE

The extraordinary manticore, with its body of a lion, the tail of a scorpion and the face of a man with three rows of teeth no less, has its roots in Persian folklore. Some also say it has the voice of a trumpet, blood red eyes and the ability to shoot the quills from its tail.

▶ Mapping out the human face over the lion's head is an interesting exercise. As with all human faces, the outside edge of each eye and the centre of the mouth form an equilateral triangle, which intersects the edges of the nostrils. This is true even when the face is contorted in a fearsome roar like this one. The human ears usually extend from the top of the eye to the bottom of the nose, although when drawing a fantasy creature like this, it's okay to bend the rules a little – so long as you know them in the first place.

Note how in this facial position, the skin folds into a frown above the nose, the eyebrows are drawn down to meet the inside corners of the eyes and stress lines appear around the mouth.

▶ The manticore's mane surrounds the head like a contiguous mass of hair and beard, and this blends the human head into the lion's torso very effectively. The body, positioned towards us, is foreshortened slightly and the scaled-up scorpion's tail is curled and barbed ready to attack. The front paws are off the ground, suggesting that the manticore is leaping forwards, as the weight of its body is not supported by its hind legs either.

To practise this, find a reference picture of a lion and try to draw it with the face of a human – maybe your own – and the tail of a scorpion.

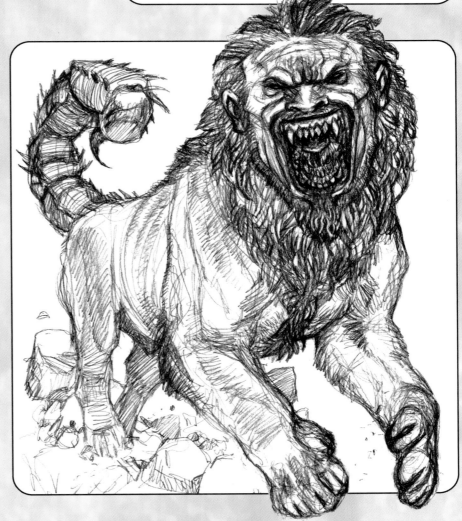

THE MERMAID

Not all human hybrids are male. In fact, you could try drawing a female centaur or minotaur, but here is a creature that is most definitely feminine: the mermaid, half-woman, half-fish.

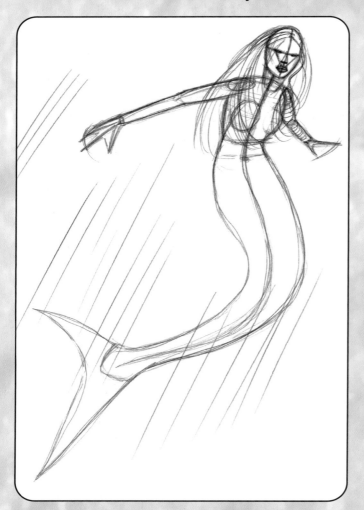

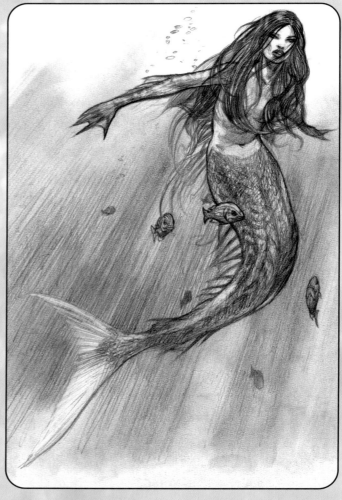

▲ The human female form is usually portrayed as less muscular and more elegant than the male. Her curves are smoother with wider hips, slimmer waist and shoulders and a bosom.

A gently curving action line provides the perfect starting point. Draw the ovoid shapes for her head and torso, long, slightly tapered cylinders for her arms, floating out to steady herself underwater. Her left arm foreshortens into the distance. The human portion of the mermaid becomes a fish at the hips, with a sweeping tail in an extended cylinder shape terminating in a graceful fin.

Centre lines on the head help you to place markings for the eyes, nose and mouth.

▲ Her slender arms terminate in hands with amphibian-like webbed fingers and her beautiful long locks keep her modesty intact. Her tail and arms have been given a sheen of delicate scales. Soft fins have been added to the back of her forearms and to the back of her tail.

Thicker, darker eyelashes are always more feminine whilst slightly slanted, cat-like eye shapes and full, pouting lips are often very attractive. Avoiding drawing the edge of the nose when face-on or in three-quarter view and indicating high cheekbones can also help create an attractive female face.

Fine pencil lines radiating out from above suggest the sun shining through water, while a few fish and some air bubbles are enough to confirm that the mermaid indeed inhabits the cool blue sea.

After perfecting the mermaid, perhaps you might like to try drawing a merman?

THE SPHINX

The Greek sphinx, unlike its Egyptian counterpart, has a woman's head and bosom, the body and legs of a lion and the wings of a bird. Legend says that she blocked the way to Thebes, eating or strangling those who could not answer her riddle, until one day she was bested by Oedipus, threw herself from a high rock and died.

◄ With the torso of a woman which transforms into the rear of a lion, getting the proportions on the sphinx correct is always going to be tricky. The key is in the creatures sharing the same central spine and adjusting the relative size of their bodies so that they fit together seamlessly. The woman's waist widens into the hips of the lion, whose hind legs are much wider apart than the woman's might be.

Her arms, reaching straight down to the ground support some of her weight as she leans forward. Her human upper arms gradually change into a lion's front paws. Again, marking centre lines on the three-quarter view head allows the correct placement of facial features.

▶ Wings sprout out from the shoulder blades of the sphinx's back, curving upwards, boasting three layers of overlapping feathers. The end of the lion tail curls up from the ground, giving the picture an impression of movement.

An elaborate chain mail garment and head covering add a certain majesty to the figure, the flowing hair and catlike good looks are suitably beguiling, while the clawed feet are a reminder that she is part-beast.

Intricately rendered in a scribbled fineliner technique, the image portrays the glamour and grandeur that you might expect from a Greek sphinx. A real femme fatale!

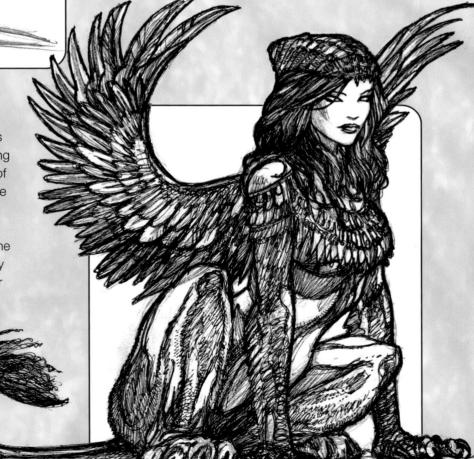

More Creatures of the Air

Flying is a common fantasy for humans so it is no surprise that many beasts from mythology and fantasy have wings. You have already been introduced to many winged creations and now here are some more flying creatures for you to study.

THE GRIFFON WITH AFRICAN QUEEN RIDER

This hybrid beast, with the body of a lion and the forelimbs and wings of an eagle, can also be called the gryphon, or even the griffin. A composite of the king of birds and the king of beasts, it is truly a majestic creature and legends of its existence stretch back thousands of years. This particular griffon is tame and will be ridden by an African queen.

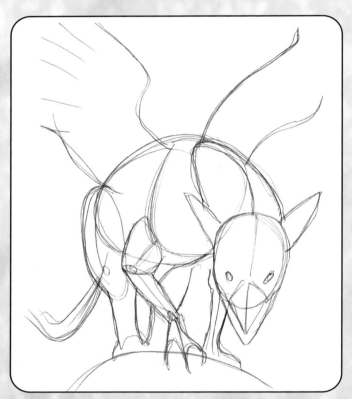

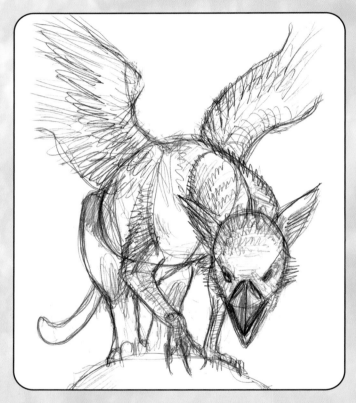

▲ For simplicity, the griffon and its rider will initially be considered separately. Atop a rocky outcrop, the griffon's body is almost crouching, back arched, with its spine and tail creating the action line. Note that the head is seen full on while the body is placed at a three-quarter view.

Ovoid shapes represent much of the beast's body, with the large torso shape dominating the very centre of the picture. Extended ovals form the rear thighs, neck and head, the latter of which terminates in a cone shape. Cylinders for the legs and arms can be sketched in, while large wings extend out from the shoulder blades.

In a pose like this, there are a lot of overlapping body parts, so to make it convincing, try to visualize the animal in three dimensions. Draw in the hidden parts of the body and if necessary sketch the pose from another angle so that you fully understand what you are trying to draw.

▲ Making preparatory sketches can be of great benefit to the finished drawing. Quickly sketching in feathers, facial features and small details on a separate sheet of paper can help you make adjustments and alterations and decide what to leave in and what to leave out. You can experiment with lighting and rendering, pose adjustments and make sure that the composition works so that your fantasy creature looks convincing. At the same time, you should try not to lose the immediacy and energy of the initial idea. Over-planned drawings can end up looking static and lifeless.

Using a quick scribbling technique, the direction of fur and feathers can be mapped out over the creature's body. From these original layouts, it was decided that the head of the beast was a little too large and that the ears were too high on the neck.

► Your rapidly improving understanding of the human anatomy will again come in useful here. The slender necked African Queen, with bow and quiver full of arrows sits on the griffon in a distinctive saddle.

One hand holds the reins of her steed. Her face is in profile, looking to her left which helps to balance the image. Her right forearm and both thighs are extremely foreshortened, as they are pointed almost directly towards the viewer.

Note how the bow and quiver both sit at about forty-five degrees to the upright figure, perfectly balancing this composition within the entire picture's layout.

► The Queen will want to control her griffon, so it will have to be saddled and reined. This image is a separate study, originally drawn to work out how the reins would fit over the griffon's head and beak, but finished off in pencil as an illustration in its own right. Based on a photo of a horse's reins, these were adapted to fit the head of the griffon. This close-up profile also gives the opportunity to figure out various details of the griffon's head and beak, particularly the characteristically large furry ears.

◄ Now it's time to put together all your disparate sketches, layouts and references into a single image, taking care to make sure that the rider is 'seated' correctly on the griffon. More precise detail including the position of the feathers, the direction of the fur, the Queen's hair, attire and sundry other facets should be refined and nailed down at this penultimate stage. Special consideration should be given to the wings, their attachment to the body at the creature's shoulders and the placement and overlap of the rows of feathers. From this angle, you can see the top of one wing and the underside of the other.

The transition between the griffon's lionesque body and eagle-like front talons should be figured out and also consider how the fur, feathers and scales should be integrated. A brush should be added to the end of its curling tail and the reins can now be placed correctly.

► The final image here was heavily rendered in pencil on a coffee-stained sheet of cartridge paper, reflecting the traditionally golden brown hue of the beast. White highlights were added with a chinagraph pencil. With the full moon in the background, most of the figurework is in shadow. The top of the griffon's left wing reflects some of the light, while the underside of its right wing remains in shadow. Tufts of fur, predominantly on its right forelimb, also catch the white moonlight.

A white glow behind the rocky mound and the lower part of the beast's legs helps to pop the figure forward, away from the background.

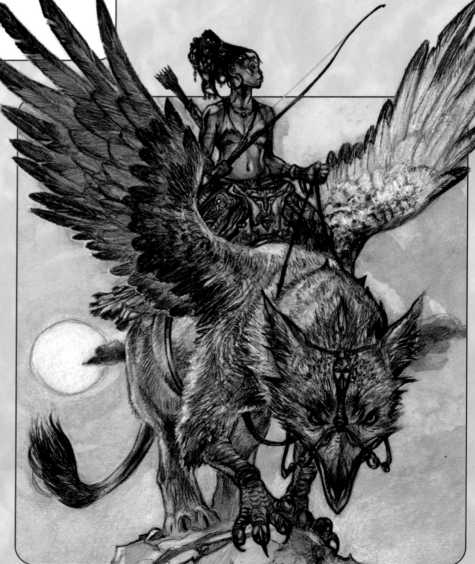

THE PHOENIX

The famed firebird, the phoenix rising from the ashes, is the immortal bird of myth. The descriptions and images of the bird vary greatly from culture to culture, from Egypt to China to Russia, but the bird's quintessential characteristic is always that it renews itself by fire.

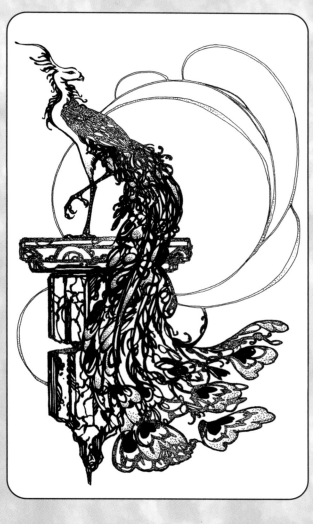

◀ Inked in a hollow, art-deco style, the phoenix stands on top of a Roman pillar. The bird looks behind itself and pauses with one foot in the air, about to take a step forwards. The main stems of its tail feathers sweep down in a gentle curve, splitting off and blossoming into a beautiful decorative, almost floral design.

▲ Because of the number of different variations of the phoenix, its portrayal is to a great extent open to your own interpretation. The Egyptian phoenix is described as more like a heron or stork, while the Romans saw it as large as an eagle or similar to a peacock. This version of the phoenix is a graphical interpretation based on a peacock-like bird with an ornamental plumage. The body is based on an oval tilted at approximately forty-five degrees, with another oval drawn inside to represent its wing. A snaking neck joins this to the oval head and two tapered cones form the top of its legs. Loose, wavy lines provide a basis for its decorative tail.

◀ This highly stylized approach was created by inking both sides of the pencil lines and then either filling them with solid black, shading them with small dots or leaving them white. When all pencil lines are erased, this leaves you with the distinctive effect seen in the main picture.

THE VAMPIRE BAT & THE THUNDERBIRD

A stock creature from horror stories, the vampire bat is the transformed body of Count Dracula or another vampire. This creature is unusual for this book, because blood-sucking bats do actually exist in the real world – although fortunately they do not transform into human vampires.

▶ The image of the screaming vampire bat flying into its cave was rendered by using a traditional ink line and wash technique. You will be familiar with the wings already, as these provide the basis for many dragon wings. Its body seen head-on like this is entirely foreshortened.

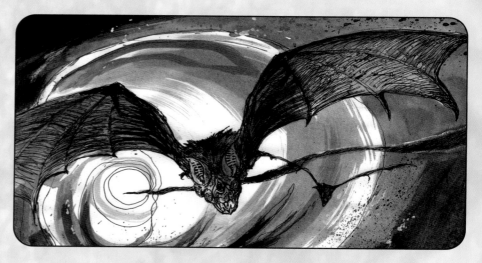

◀ The bat's face is like every other face – essentially symmetrical with two eyes, nose, mouth and ears. The eyes, very small and beady, are placed halfway up the head, like the human's, and the wide mouth is filled with pointed, blood-sucking fangs. The large, open nose and huge tear-shaped ears almost cover the remainder of its face, apart from a visible part of the domed forehead from directly above the beast.

Once again, the skin texture is indicated with wrinkles that roughly follow the contours of the shape of the body and limbs.

The thunderbird is a mythical creature common to the Native Americans and often carved into totem poles. It is reputedly huge and creates storms wherever it flies – its beating wings cause thunder and its blinking eyes generate lightning.

◀ Based on the bald eagle, this view of the thunderbird is from above, looking down on the landscape below. Accurate anatomy is secondary here to the impression of speed, wind and rain. This dynamic and atmospheric image was produced with soft pencil on a heavily textured canvas paper, using long loose strokes with judicious use of smudging.

ELEMENTALS

Alchemic elementals are mythological entities that are composed of the fundamental elements of nature: fire, earth, air and water. These beings can be summoned into life by sorcery.

Illustrating these extremely fluid and ever-changing spirits can be a challenge even for the experienced artist. There is certainly no right or wrong way to draw this type of creature, so have fun and see what you can do.

▲ The air elemental, composed of steam or clouds, is depicted by vague pencil shapes, its ethereal facial features and shape suggested by shadow. When drawing smoke, steam or clouds, always use loose, random lines. The soft, light effect is enhanced by subtle smudging.

▲ Water, like air, is transparent, so this elemental is given form by swirling masses of bubbles, twisting and darting in the deep. A fish-like head is subtly hinted at, with a shiny bubble for its eye. A few frightened fish swimming away adds to the impression of a fearsome aquatic spirit.

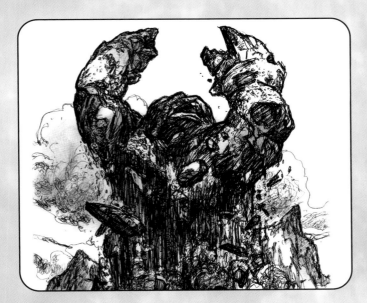

▲ A creature erupts from the rock, formed from the earth itself, heavy, hard-edged and aggressive. This drawing, combining both human anatomy and landscape observation, is given life by the upward movement lines and falling debris. Harsh lighting and strong shadows add power and drama to the image.

▲ A white hot fire elemental leaps towards the viewer, a body comprised entirely of golden flames. Against the black background, the figure relies entirely on flame-shaped brush strokes in red, orange, yellow and white, its face suggested by high-contrast areas of black and white. Spatter marks add further energy to the picture.

Monsters of the Sea
CUTE SEA MONSTER

Creatures from the deep appear in many books and movies but there are so many weird and wonderful entities that roam the unexplored waters of the Earth that it's difficult to fabricate anything more fantastic than those that already exist!

Here's something a little different for this book – a kind, cute, friendly-looking critter which you can learn to draw and maybe paint, too.

▶ The cute sea monster is constructed entirely from spheres and ovoids. A slightly extended egg shape forms its body, with four flattened ovoids attached to the lower part at all four 'corners' for its fins. Another, larger, flattened ovoid at the rear of the creature, gently curved, will become its tail.

Its fat neck is a flattened sphere, attached at the front of the body a little higher than centre and actually wider than the almost spherical head. The head is almost entirely divided by a very long smiling mouth and a small beady eye can be added about halfway up and towards the back. A few contour lines can be added across the back of the creature.

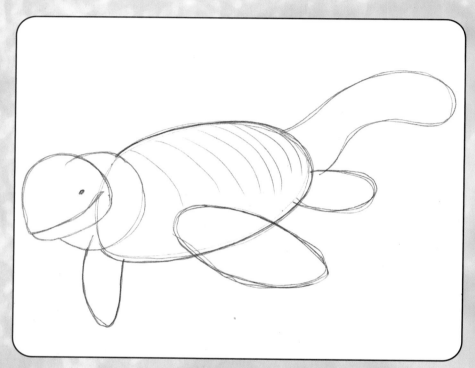

▶ Start to refine your outlines, gently sketching at first, then adding more pressure as you 'find' the lines you want. Add some short, rounded frills along the back of the creature, as well as on its tail and fins. Cut in some thick, shallow finger-type shapes to the ends of the fins. Create a thick 'top lip' above its mouth, modify the mouth line and integrate the neck into the body.

Keep in mind the creature's three-dimensionality as you add detail and apply rendering so that your image does not flatten out. Add some spotty markings along the top of the creature and on its tail and fins, following the shape of your contour lines. Think about your light source

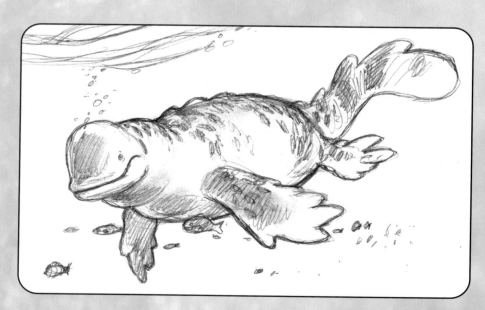

(obviously coming from above the water) and add some shading. A few lines will suggest water; add some bubbles and the odd fish or two, and there you have it! A drawing of a really cute sea monster.

▶ If you wish to paint your cute creature, you can transfer the outline of your image to some thicker paper, board, or even canvas. You can use watercolour paint, gouache, water-soluble acrylic, or even oil paint, which was the medium used for the finished picture you see here.

It is always advisable to experiment with colour schemes and lighting effects by doing some brief 'colour sketches' before laying down paint on your final canvas. Here, the balance of the darker areas and the fingers of light radiating through the water are the main concern.

▶ This stunning final image can be created with surprisingly few colours – just blue, white and a little brown. The rays of light and the bright patterned highlights on the monster's back create a very realistic and atmospheric effect. The dark, simply rendered, out-of-focus sea bed provides ample contrast to the lighter figures.

Painting, and in particular oil painting, can take some time to master but images like this one are not beyond the dedicated student. You may like to try using watercolour washes over inked outlines, or some of the other techniques suggested in this book, as an alternative to oil paint.

THE LOCH NESS MONSTER

Nessie is certainly the stuff of legend but if you were to believe the locals then you would be sure that he really does exist. There are many theories about what kind of creature the Loch Ness monster actually is but, as no one actually knows, you are safe to invent your own.

▶ Start with an expressive action line, a long, curving, twisting shape which you can flesh out into a long cylinder with a pointed cone at one end for its head. Add two sets of tear-shaped fins, although the right front fin is all but hidden.

In fact, the body thickens slightly behind the head and after the first pair of fins. The tube shape also flattens out at the final tail section. Draw on the contour lines which are vital in describing the shape of this body.

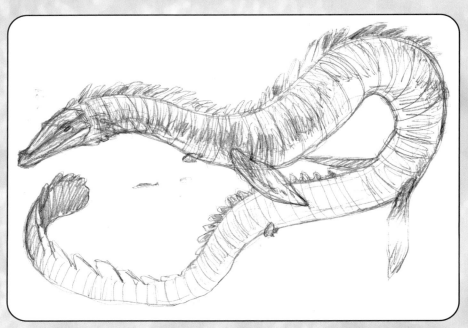

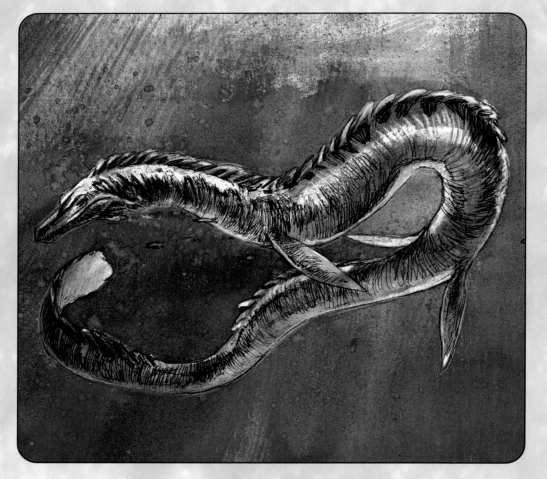

◀ The ink rendering on the figure closely follows the contour lines and also suggests shadow, as well as being used to draw the outline.

Again, the obvious position for the light source is above the water and the rays of light reflect bright white off the back of Nessie's eel-like form. Note how the narrow shadow of the frills cast on its body on the top right of the picture really enhance the shape and three-dimensionality of the picture.

This evocative image was rendered with fineliner pen, painted with a limited watercolour palette and highlighted with white paint.

THE GIANT SQUID

The famous nemesis of Captain Nemo in Verne's *20,000 Leagues Under the Sea*, the giant squid is another fantasy creature that actually exists in the real world. Originally believed to be a purely mythical being, along with the even larger Kraken of Scandinavian legends, it is a fearsome predator.

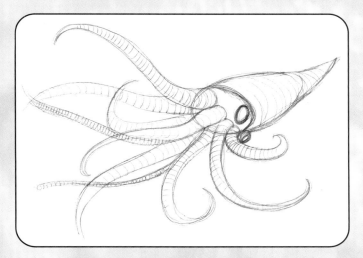

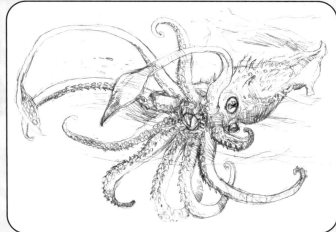

▲ This breakdown of the creature's anatomy shows that the giant squid consists simply of a conical head and multiple tapered cylindrical tentacles: eight arms and two longer, thinner tentacles terminating in large suckered 'clubs'. Suckers also line the inside of each of its shorter 'arms', which are actually shaped like cylinders split lengthwise. It also sports two delightfully large eyes on the lower part of the head.

▲ Another study, or preparatory drawing, helps to define the exact pose, composition and arrangement for your underwater monster. With ten flailing limbs, care should be taken to arrange them into an elegant composition which gives the impression of the beast floating, suspended in water. This sketch, although similar, contains many differences when compared to the final version.

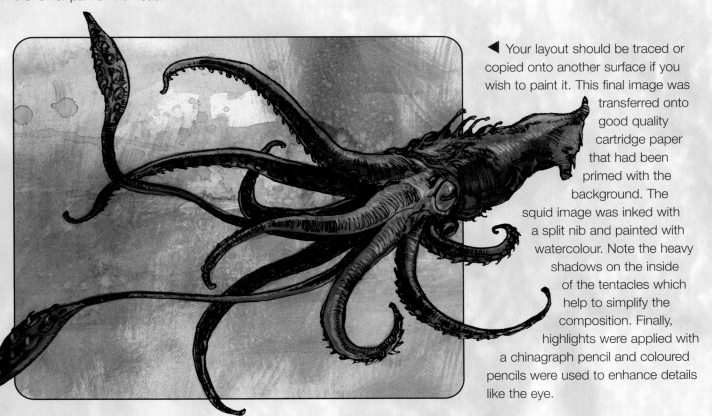

◄ Your layout should be traced or copied onto another surface if you wish to paint it. This final image was transferred onto good quality cartridge paper that had been primed with the background. The squid image was inked with a split nib and painted with watercolour. Note the heavy shadows on the inside of the tentacles which help to simplify the composition. Finally, highlights were applied with a chinagraph pencil and coloured pencils were used to enhance details like the eye.

Chimera
THE CHIMERA

The dictionary definition of a chimera is a creature made up from genetically different parts, which could actually apply to almost all of the fantasy beasts featured in this book. Take a look at two of the most popular chimera and then maybe create your own. The original description of the fire-breathing chimera is from Homer's classic *The Iliad*, where the creature is described as part lion, part goat and part serpent. It was finally slain by Bellerophon who rode in on Pegasus.

There are many different interpretations of chimera, mixing up different parts of the animals. This particular visualization adds a pair of wings to the back of the beast.

▶ Take a look at the constituent parts of the creature before combining them. Rather than have the front half of a lion and the back half of a goat, we'll base the whole body on the lion. The king of beasts leans forwards, pawing the ground in anger, with the weight of his body sustained mostly on his partly obscured right leg.

Simple spheres and cylinders comprise the creature's body, which is viewed from somewhere between three-quarters and profile, so the constituent basic shapes overlap slightly. The main ovoid of the torso tapers back from the large chest to a slim waist. Its chunky, powerful-looking forelimb is emphasized by the perspective of our view. The bent knee of its left hind leg creates a foreshortened shin. The large mane obscures its neck and shoulders.

▶ You will need to pay special attention to the heads and faces of the lion and the goat, as you may not have drawn these before. Despite sharing the same features like eyes, nose, ears and mouth, the difference is marked.

The lion has erect, almost cute, bear-like ears while the goat's are long, pointed and floppy. The lion's flat face is in contrast to the longer snout of the goat. The lion sports an impressive array of pointed teeth while the goat proudly bears a pair of twisted horns.

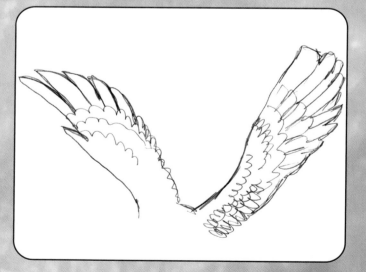

▲ As you have learned, wings can conveniently be situated on top of the shoulders of most creatures and a chimera will be no different. Interesting to note that from this view, you can see the top of one wing and the underside of the other.

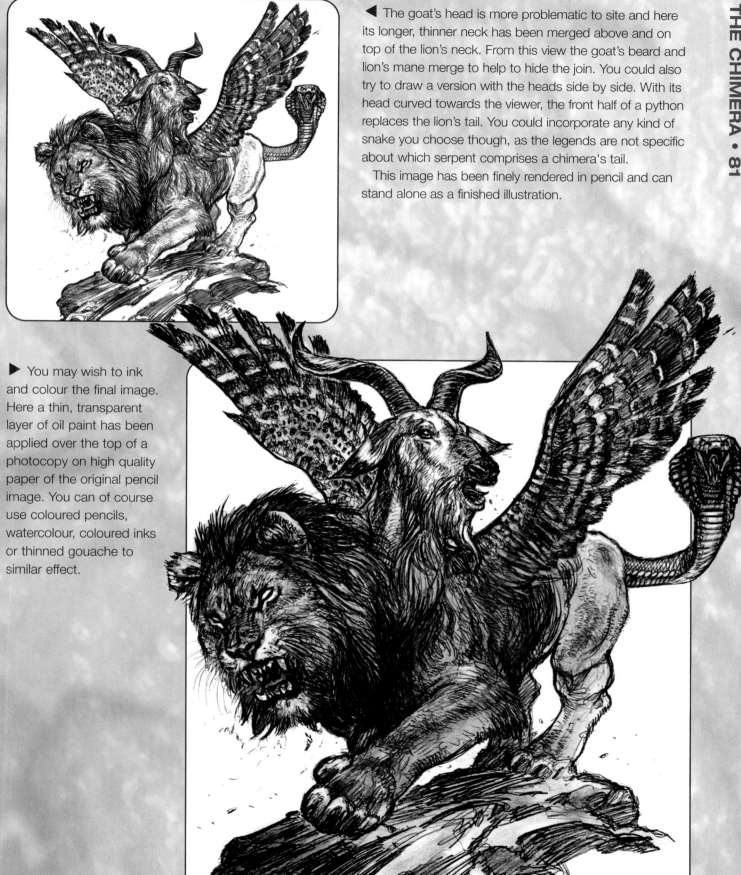

◄ The goat's head is more problematic to site and here its longer, thinner neck has been merged above and on top of the lion's neck. From this view the goat's beard and lion's mane merge to help to hide the join. You could also try to draw a version with the heads side by side. With its head curved towards the viewer, the front half of a python replaces the lion's tail. You could incorporate any kind of snake you choose though, as the legends are not specific about which serpent comprises a chimera's tail.

This image has been finely rendered in pencil and can stand alone as a finished illustration.

► You may wish to ink and colour the final image. Here a thin, transparent layer of oil paint has been applied over the top of a photocopy on high quality paper of the original pencil image. You can of course use coloured pencils, watercolour, coloured inks or thinned gouache to similar effect.

CERBERUS

Cerberus, the three-headed dog which guards the entrance to the underworld, is a variation on the chimera-theme. This multi-headed canine with serpent's tail and Medusa-like mane may, depending on which myth you believe, either bite you upon your arrival in Hades, or tear you to pieces if you should try to get out.

▶ Despite the complex-looking final illustration, the first stage image shows that the basic shapes are fairly simple; one egg-shape for Cerberus' body, rounded cylinders for each part of its limbs and three spheres for its heads. Add a tail, some cones on each of the heads to indicate snout and ears and there you have it.

Of course, finding the right position for each head so that the creature looks convincing can be a challenge. Here, one central head is lower, flanked by two heads on either side in a slightly higher position. The addition of the arrangement of tiny snakes helps to hide the potentially awkward-looking neck joins and also adds another layer of otherworldliness and ferocity to the beast.

Final rendering was achieved with a split-nib pen and dark brown ink. The fine line work helps to describe the shape of the beast with the fur textures which radiate away from the face and the contour lines around the snakes' bodies. Tempting as it may be, do not cover every part of the body in fur as white areas are necessary to add contrast and form. This is especially effective around the eyes and mouth of each of the wolf-like heads.

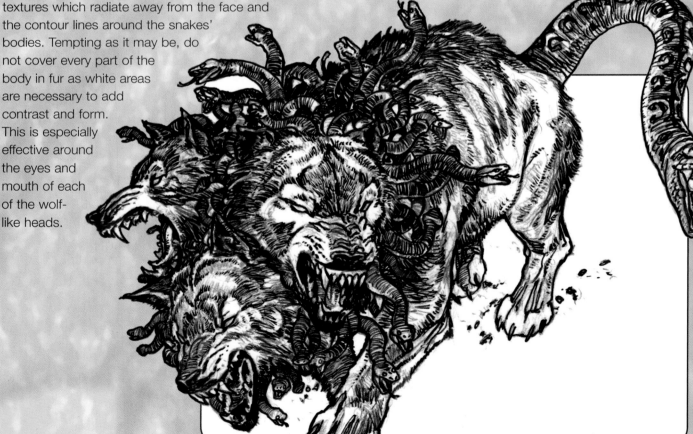

INVENT YOUR OWN BEASTS

By now, you will probably have figured out that by combining several parts of different animals, you can create your own chimera or fantasy beast. And why not? But don't take the matter lightly. You will want to make your creature anatomically convincing and visually arresting. You should perhaps invent a legend where it takes the starring role and you will certainly want to give it a name.

▶ The Gondat, or the 'Lord of the Monsters' as it is affectionately known, is based on an unearthly cross between a wild boar and gorilla, with one large central eye inspired by the Greek mythological monster Cyclops.

Simply constructed from a few chunky spheres and cylinders, the beast is all about bulk and power. The abnormally large head and pointed teeth leave you in no doubt that this is a creature not to be messed with.

The final naturalistic rendering makes a rather cartoony design look realistic and believable. Fineliner hatching follows the contours of its body and marker pen and coloured pencil are used for subtle colours.

▶ Part camel, part flamingo, the Skitta roam the desert plains looking for food and trying to avoid the attentions of the Gondat. By combining two entirely different species – a bird and a mammal – but those which share a similar physique, an effectively convincing fantasy beast can be created.

Simply fashioned from two small ovals, some lines for gangly legs and a similarly long neck, the pencil layout stage shows an alternative leg position. The completed Skitta landscape was rendered in pen and ink and coloured with watercolour and coloured pencil.

Setting the Scene

Drawing fantastic and spectacular creatures like dragons and centaurs is not the whole story. You don't necessarily want them to be floating around on a plain white sheet of paper; ideally they need to be set in the context of appropriate surroundings. Your figures could inhabit a lush, enchanted forest or a barren, rocky desert, soar across a wide open sky or dive to the depths of a turbulent sea.

TREES & PLANTS

Plant life in fantasy can be just as varied. There are many exotic plants which exist in the real world, or you can use them to inspire new creations.

▶ The demon cactus is fun to draw, as you don't have to worry about things like accurate anatomy. It's easy to build a drawing up from not much more than a doodle. A few wobbly finger-shaped lines is all you need as a base. The twisted grooves down the length of the cactus are shaded to show depth. The spines come out of the plant at right angles, but note that where they are pointing at the viewer straight on they are drawn as little more than dots.

▶ This chunky plant looks a little like a stunted palm tree, albeit with thick, solid leaves. A short, fat, curved cylinder and a number of randomly shaped ovoids are all you need to start. Light direction is important here, so that you can add in shadow to give the leaves and trunk depth. The dark shadows then really help the plant pop off the page.

▶ This jungle plant is another palm-like tree, with segments resembling the skin of a pineapple and long, floppy leaves sprouting from the top.
 Build up the drawing around the oval, adding the slim trunk and leaves. Criss-crossed contour lines help to give the trunk shape. Again, heavy shading on the underside of the leaves really clarifies the shape.

► This unearthly tree is called a baobab and Arabian legend has it that the devil plucked it up out of the earth and thrust it into the ground upside down, leaving the roots in the air, which is pretty much what it looks like. Also known as the 'monkey bread tree', it is found on the equatorial savannahs, where some claim it lives for as long as several thousand years.

This one's all cylinders and great fun to draw. Contour lines around the bough provide both shape and texture.

► This tree is probably more familiar. It's a birch and has the common traits of a trunk and numerous branches, splitting off at certain intervals in a random, yet somehow predictable, way. The gentle curve of the trunk is a good place to begin and with practice you will get a feeling for the application of branches.

You can then start to thicken the trunk, slightly tapering as it goes upwards, and start applying the leaves over the ends of the branches in neat scribbled clumps. Again, this is something very organic which will come with practice.

▲ Now for something a little more complex, a little more intuitive. This old oak tree is gnarled and slightly scary. You can try building up its structure with blobs of scribbles, its branches twisted by the winds and surrounded by long flowing grass.

Don't attempt to draw in every leaf or every blade of grass. It's only important to give an impression of leaves and grass by scribbling and sketching. Heavier shadows on the branches and under the leaves help to give the tree three-dimensionality.

ROCKS & CLOUDS

Rocks are even more fun to draw as you don't have to worry about leaves and bark and branches. But the relatively featureless rock forms require a little more skilful shading to ensure they instantly give the impression of what they are supposed to be.

▲ Rocks and boulders come in all shapes and sizes, often smoothed and rounded by winds and tides. Distorted egg-shapes are a good starting point, although the real challenge lies in making them look heavy and textured. Random chips, divots and cracks should be indicated towards the edges, following the contour of the stone. Strong overhead lighting casts strong shadows, indicated by line hatching.

▲ In this different type of formation, the brittle rocks flake away, leaving sharp, pointy forms. You need to find alternative ways to describe the various textures. Here, the long, vertical lines and craggy tops reinforce the natural texture of the outcrop.

▲ This rocky mountain landscape has been rendered with different weights of pencil shading to indicate depth and distance between the foreground and background. The darker, softer pencil work brings the objects closer, while lighter shading sends elements towards the back.

The mist surrounding the peaks also helps to neatly add separation between the mountain ranges. Use an eraser to soften the edges of the white areas while still leaving some of the pencil to show through so that it looks even more like a mountain mist.

▲ Rocks need not be barren of course and this is a nice example of some boulders covered in moss created with coloured pencils in greens and browns. Note how just a few circular scribbles are all that is needed to indicate the moss, while strong horizontal lines add texture to the rocks.

▲ This is probably as minimal as you would want to get. This simple desertscape is suggested with just a few horizontal lines and oddly-shaped ovals with some basic shadow. It's actually trickier than it looks to get it looking convincing, so try it yourself.

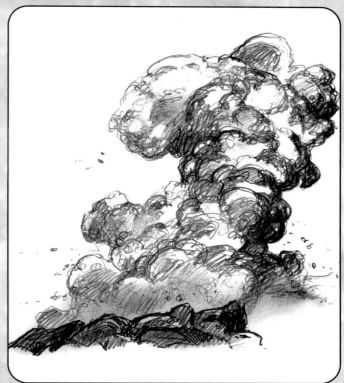

▲ A volcanic eruption creates huge amounts of clouds of smoke and gas and suggests exactly the sort of habitat that a dragon might like to spend time in. Clouds break off from the central eruption as debris is thrown into the air.

Study the varied shading of the smoke, darkened on the right hand side and under the tall offshoot on the top left. Subtle smudging at the bottom of the cloud helps to defocus the smoke as it exits from the volcano.

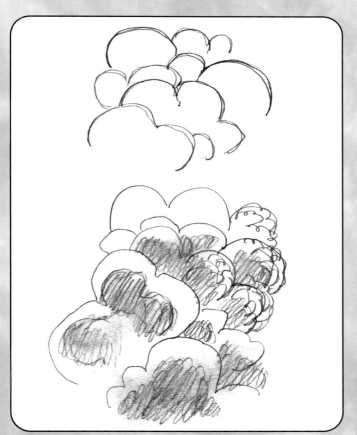

▲ Any kind of gaseous substance is deceptively difficult to capture on paper. Creating random circular shapes of different sizes that are neither too regular nor too arbitrary can be challenging. One layer of shadow within the individual shapes lends a degree of depth. It's worth taking some time next time you are outdoors to take a look at some cumulus clouds.

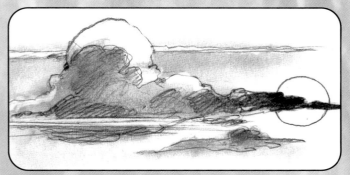

▲ A single cloud mass hangs across the sky as the sun sets. Note the smooth grey tone created with the soft pencil smudging, describing both the colour of the sky and the shadow of the cloud. Note how the part of the cloud which covers the sun is shaded much darker for contrast, making the sun appear brighter.

SEASCAPES

One of the interesting things about drawing water is that it is transparent. You can't actually draw water itself, so you have to draw what it reflects or find another way to indicate it. Sometimes it gets a little muddied up but generally it's a surface that reflects the blue of the sky, boats or the adjacent land. The deep sea can appear dark, even black, while ripples, waves and crashing surf are other ways you can use to indicate the presence of water.

► Indicating an underwater scene is another challenge. The first image suggests the compositional layout of the underwater rock masses and, like the mountain landscape you saw earlier, the dark shape is closest, with the lightest shape furthest away. Fish are usually a dead giveaway. Fish simply don't float around in the sky the way they do underwater, so always try to put a few of those in your underwater scenes. Looking upwards towards the water's surface, we can see the shafts of light filtering through the murky darkness of the sea. It's another effective indication of water.

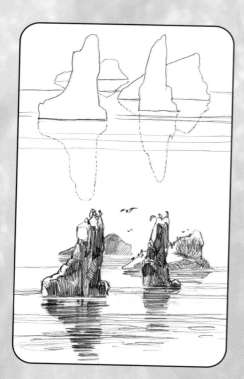

▲ This is a great example of these techniques. The sea reflects the rock formations but it is broken up a little by the ripples on the water's surface. In a sketch like this it's enough to suggest the reflections by a silhouette of the reflected shapes. The light source from behind casts a shadow on the rocks so we have a nice dark shape to reflect.

▲ Colour can also be a very useful device. Using a wide brush, with a mixture of wet blue washes quickly applied, can give a fluid, convincing impression of the sea. Even drips and runs in your paint will reinforce the impression of water, in contrast to the solid-looking rock formation rendered in coloured pencil. Using an old toothbrush to dip in the paint, you can spray on some spatter marks by flipping your finger over the bristles. Instant sea spray as the waves crash against the rocks!

► You can try mixing your newly discovered sea, rocks and cloud rendering techniques to create a composite picture. A new volcano pushes its way out from the sea bed to vaporize sea water as it rises into the air, spewing out molten lava as it goes. Using watercolour paints, pencil and fineliner pen, this image conveys the thrilling turbulence of the scene.

LANDSCAPES

Landscapes you create, into which you place your fantasy figures, can be incredibly diverse – mixing up trees, plants, rocks, desert plains, mountains, rivers, volcanoes and seas into your own unique backdrop. Here are a number of quick sketches, each suggesting a different type of environment and perhaps inspiring the creatures who will inhabit them. Look at the sheer variety of picture compositions available.

Using some of these landscapes as a starting point, you can work them up into finished illustrations, or even adapt them and create your own dramatic backdrops. You can get further inspiration from postcards and pictures in travel books of exotic locations.

PUTTING IT ALL TOGETHER

With all the knowledge and skill that you have amassed so far, it's time to create a picture that combines drawing and painting technique, composition, figure drawing and landscape.

▶ Before embarking on a major project, you should always make some preparatory roughs in order to figure out your picture composition, or to arrange and balance the elements in a pleasing and attractive way. Quickly roughing out a number of alternative sketches is a good way to see which layouts will work and which won't. Make sure you have the figure's proportions approximately right and that the viewpoint or perspective is consistent and accurate. It's also a good idea to quickly shade in areas of shadow to check whether the picture balances tonally.

This image of a pterodactyl-like dragon atop a rocky outcrop places the foreground figure to the right of the picture. The creature is facing to the left from the viewer's

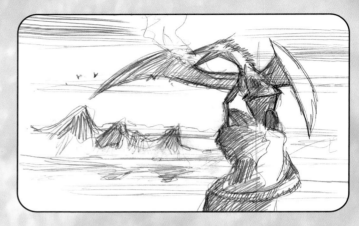

perspective and its outstretched wing is counterbalanced by the row of mountains underneath.

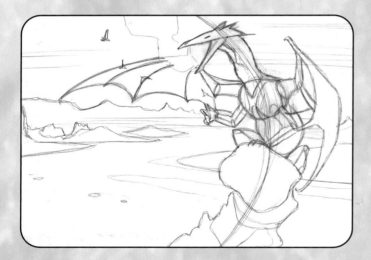

▲ Once the rough composition is worked out, you can scale up to full size and start building the figure more precisely. Note the beautifully simple action line, a smooth, consistent curve incorporating the spine of the dragon as well as the rocky outcrop on which it sits.

Its torso is represented by two roughly spherical shapes – one for the chest and one for the hips. A split cone forms its open-mouthed head. Cylinders form its neck and limbs and wings extend from its shoulders. We can see almost all of the right wing's underside, while the left wing has small parts of its inside and outside visible. Most of its hind limbs are hidden behind the rock to which it clings.

Landscape elements of mountains, water and sky should also be indicated at this stage to make sure the composition works well at this scale.

▲ Even though this image will ultimately be painted, it may help you to work out the areas of tone, light and shade, by sketching them all in at this pencil stage. Adding contour lines, skin folds and textures to the dragon's hide can also be beneficial.

Visualize the light source behind the dragon, off the picture to the right as the viewer looks and low in the sky. This illuminates the back of the dragon's wing, the right side of the rock, reflects off the water and diffuses through the smoke escaping from the dragon's snout.

◀ When you are happy with the pencil drawing, you can transfer it to another sheet or board for painting. If your original is clean enough you may want to paint directly over the top of it. You may wish to create a colour guide before proceeding to work out your exact colour scheme.

With the simple choice of blue and a couple of brown shades, an acrylic wash is laid over the pencil drawing. This provides an excellent base and also confirms that your colour scheme is working as expected. Leave plenty of areas white for maximum contrast and impact.

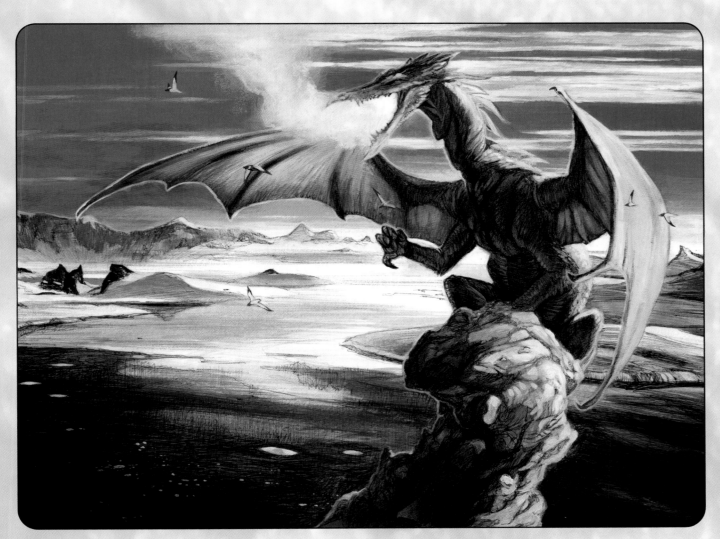

▲ Finally, you can paint on layers of opaque acrylic, building up lighter tones over darker colours. The sky is smoothly graded tones of blue while the water ranges from inky black to icy white. White paint is daubed with some cotton wool or scrunched up tissue for a smoky effect. Short strokes on the body of the dragon in lighter colours follow the contours of the shapes, giving the figure dimensionality and a pleasing leathery texture. Red is added to the brown on the inside of the wings to give the effect of light showing through fine skin. Finally, some detail can be added with a pen to strengthen outlines and add texture in certain areas of shadow.

Further Study
ADVANCED LIGHTING TECHNIQUES

As you learned in the introduction to this book, drawing dragons isn't just about dragons – it's really about drawing. Learning as much as you can about different aspects of art and practising and experimenting will make you a better artist and therefore a better dragon artist.

Light and shadow is one of the most important considerations when rendering your picture. In the second chapter of this book you learned a little about lighting a simple block with a single light source. In nature, lighting is not always so straightforward.

There can be two or more different light sources, from different positions and with different intensities. There is also reflected light, from shiny or bright surfaces.

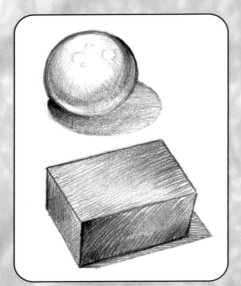

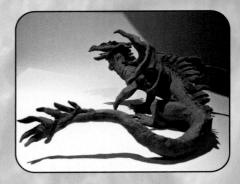

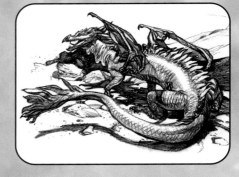

▲ A simple light source from above, slightly behind and to the left creates a single shadow.

▲ Multiple light sources from a little lower than the previous example, slightly in front and to the right cause multiple shadows of differing intensity. A reflected source also causes shadow in front of the sphere and on the side of the block.

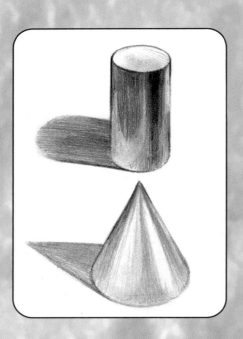

◀ Shiny surfaces cast shadows but also reflect the light and shadow from nearby objects on their surface.

▲ You can even construct your own models, light them how you wish and then draw them, making sure that the shadows fall perfectly in the right place. Here, a model of a dragon has been created out of modelling clay, carefully lit from above and then illustrated in pencil.

Making models also aids your understanding of three-dimensional shape, mass and form.

PHOTO REFERENCE

Using photographs to inform your drawing isn't cheating. If used correctly, it is an essential tool in your armoury as an artist.

Photographic reference can, however, be a double-edged sword. It can be excellent for providing visual information for what you want to draw, making sure that you have all the details of the creature or object correctly positioned and proportioned. Copy photographs too slavishly though, and you could end up with illustrations that are stiff, lifeless and lacking in imagination.

In this example, a number of photographs of animals from a visit to a zoo have been used by the artist as reference material to create a beautiful acrylic painting of an invented beast.

Pictures of a pelican, alligator and lizard have been used to inspire the picture rather than simply copied and stitched together. A large degree of revisualization is required in order to pose and lay out the composition. Pencil studies are made to get the angles and proportioning correct before the final painting is begun.

You can use photographs of your own such as holiday snaps, or you can go out and take specific reference photos for a picture that you intend to draw. You might even want to take photos of yourself in different poses that you find difficult to visualize.

You can also scan books and magazines, even images from the Internet or captured stills from DVDs. But if you are copying from these sources, do remember that they may be copyrighted by the originator and should therefore be used only as reference and not copied line for line.

SKETCHBOOKS & OBSERVATION

Observing from life is one of the most important things an artist can do to improve his skills. Simply looking at things in the everyday world and committing them to memory, such as people, animals, buildings, countryside and beautiful sunsets, can inspire and improve knowledge.

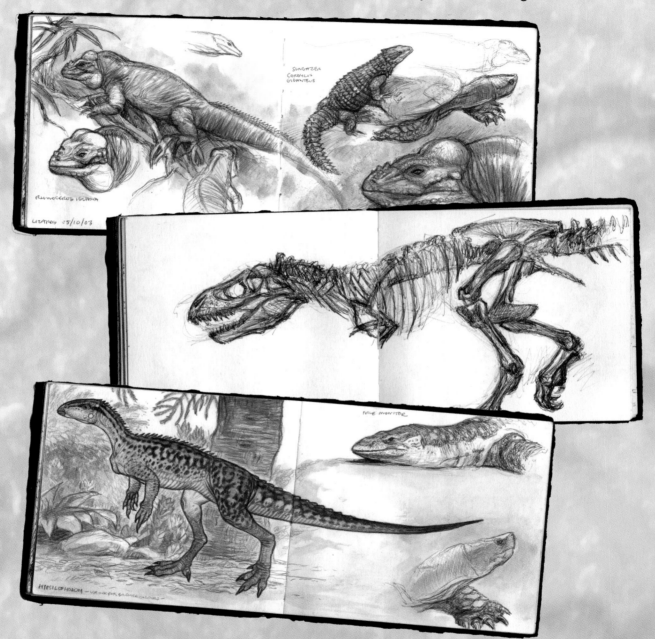

Drawing from life is also hugely beneficial. Many colleges offer life drawing classes but you can of course simply sketch friends or family and objects from around the home. Carrying around a small sketchbook is something that most artists love to do, so that ideas can be quickly scribbled down when inspiration strikes. More detailed drawings can be done as an exercise, reference or as preparatory work for a proper illustration.

You might like to buy one that is compact enough to fit inside your pocket or carry around with you. Don't buy one that's too expensive as you don't want to be too precious about your sketches – and hopefully you will be filling up the pages quickly.

The drawings here are from some sketchbooks used by the artist James McKay while on a visit to London Zoo. Dinosaur skeletons and stuffed reptiles make great reference material for creating dragons.

FINDING INSPIRATION

Inspiration for your fantasy creatures can be found just about anywhere. Reference books, magazine articles, novels, comic books, photographs, natural history books, movies, TV shows, conversations with friends or even dreams can all motivate the need to create.

Sometimes, when inspiration has deserted you, you might find that instead of looking at a blank sheet of paper trying to come up with something out of thin air, a trip to a museum, a walk in the park or watching an old movie on the TV can get your creative juices flowing again.

Pictures by your favourite fantasy artists probably also provide you with a lot of inspiration and a great deal can be learned by copying other illustrators' work. Studying and attempting to reproduce other artists' techniques is an excellent way to improve your skills, but this should only ever be used in order to educate yourself: you should never attempt to pass off other people's work as your own, as it is both morally and legally wrong.

◀ This stunning acrylic painting of an Australian landscape features the extinct giant monitor lizard Megalania as well as a number of indigenous species from down under.

◀ Dinosaurs and other prehistoric animals can provide great templates for your fantasy beasts.

There are many further how-to-draw books available to the budding student and hopefully this book has inspired you to increase your knowledge of lighting, anatomy, perspective, drawing and painting techniques and much more. Keep learning, keep practising and have fun. Good luck!

Index